MACCHINE DA CAFFÈ

Ambrogio Fumagalli

CHRONICLE BOOKS

SAN FRANCISCO

First published in the United States of America by Chronicle Books in 1995.

Printed in Hong Kong.

Library of Congress Cataloging-in-Publication Data:
Fumagalli, Ambrogio.
 [Macchine da caffè. English & Italian]
 Coffeemakers = Macchine da caffè/Ambrogio Fumagalli;
 [caption translation, Joe McClinton; photography, Cesare Gualdoni].
 p. cm.— (Bella cosa library)
 English and Italian.
 Rev. translation of: Macchine da caffè. 1.ed. Milano: BE-MA Editrice, 1990.
 ISBN 0-8118-1082-8 (pbk)
 1. Coffee making paraphernalia—Catalogs. 2. Coffee making paraphernalia — History.
 I. Title II. Title: Macchine da caffè. III. Series.
 TX657.C67F8613 1995
 016.683'82—dc20 94-45544
 CIP

Caption translation: Joe McClinton
Photography: Antonio Fedeli
Series design: Dana Shields, CKS Partners, Inc.
Design/Production: Robin Whiteside

Distributed in Canada by Raincoast Books
8680 Cambie Street
Vancouver, B.C. V6P 6M9

10 9 8 7 6 5 4 3 2 1

Chronicle Books
275 Fifth Street
San Francisco, California 94103

Coffeemakers

*O*ver the years, the subtle pleasure of sipping a cup of coffee has come to be one of life's indispensable rituals. We owe much of this pleasure to the coffeemaker. Originally no more than a simple pot, the coffeemaker has evolved into a sophisticated machine, developed and perfected by enthusiasts of the aromatic beverage.

This book examines both simple household coffeemakers as well as imposing coffeehouse machines evoking those traditional meeting places where so many people have gathered not just to drink a cup of coffee, but to argue, read, write, create, dream, and sometimes even plot revolutions.

*A*n Italian tinplate coffee urn with a spirit lamp to keep the beverage hot. The base and handles are wood. It worked by the drip principle, and was used in restaurants and small hotels. 20 by 11 inches, 6-cup capacity.

Prima metà '800

Caffettiera italiana in latta stagnata con fornello ad alcol per tenere calda la bevanda. Base, maniglie e rubinetto in legno. Funzionamento a filtro. Veniva adoperata nelle trattorie e locande. Cm. 50 x 28, capacità lt. 1,5. ➢

Detail of the handcrafted stove door.
Particolare del fornello: lo sportello lavorato artigianalmente.

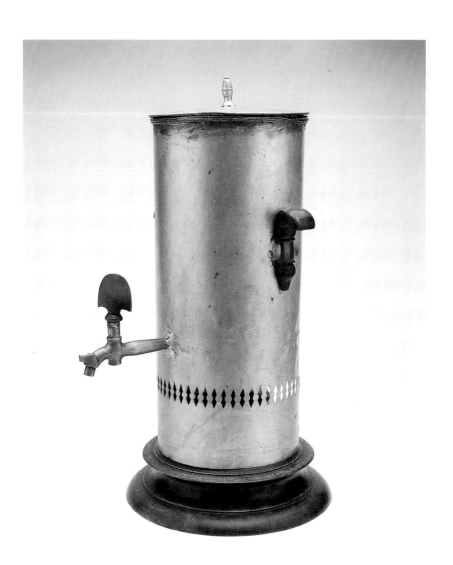

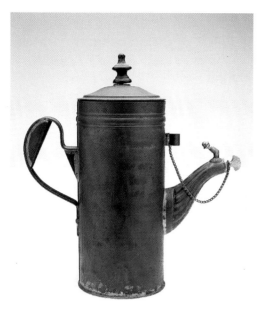

The Milanese, a practical Italian tinplate coffeemaker that extracted much of the flavor from the beans. The boiling water rose into the upper chamber, where a filter held the ground coffee. When the machine was removed from the heat, the resulting vacuum quickly drew the coffee down. 12 by 10 inches, 3-cup capacity.

Seconda metà '800

La Milanese, pratica caffettiera italiana in latta stagnata, capace di sfruttare molto il caffè. L'acqua in ebollizione saliva nella parte superiore dove separata da un filtro c'era la polvere; quando si toglieva la macchinetta dal fuoco, la bevanda, per effetto del vuoto, scendeva rapidamente. Cm. 30 x 25, capacità lt. 0,75.

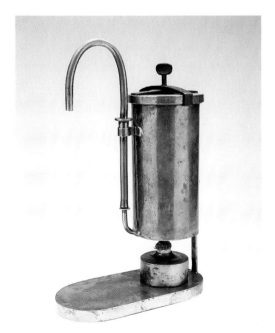

A little French
brass domestic coffee-
maker, called Le Brun
after its inventor. This
steam-pressure brewer
was heated with alcohol.
12 by 7 inches, 4-cup
capacity.

Prima metà '800

Piccola caffettiera
francese in ottone per
famiglia, detta "Le Brun"
dal nome del suo inven-
tore. Funzionamento a
pressione alimentato con
alcol. Cm. 30 x 18, capac-
ità 4 tazze.

*T*he Neapolitan, the type of coffeemaker most widely used in Italy until the 1950s. It came in different sizes and different materials, and worked very simply: when the water boiled, you turned the whole thing upside down. 10 by 7 inches, 5-cup capacity.

1860 circa

Napoletana, la caffettiera più usata in Italia fino agli anni '50. Costruita di misure e materiali diversi funzionava in modo molto semplice: quando bolliva la macchinetta doveva essere capovolta. Cm. 25 x 18, capacità 5 tazze. ➤

Detail of brass plate with the manufacturer's information.
Particolare. Targhetta in ottone con i dati di fabbricazione.

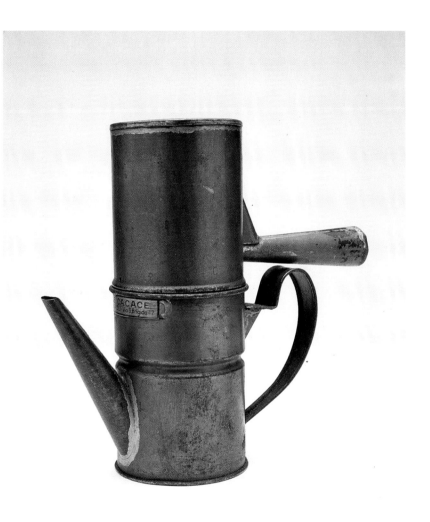

9

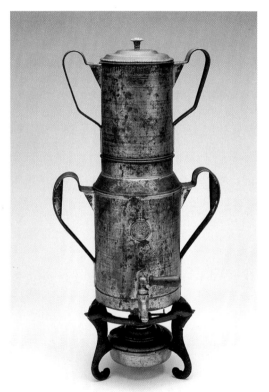

*A*n example of an Italian coffee urn designed for use in small hotels. Made of tinplate by Caudano of Turin, it is outfitted with a stove and a serving spigot. 20 by 12 inches, 12-cup capacity.

Seconda metà '800

Esemplare di caffettiera italiana in uso nelle locande. Prodotta dalla ditta Caudano di Torino è in latta stagnata e munita di fornello e rubinetto. Cm. 50 x 30, capacità lt 3.

A pair of Middle Eastern–style copper coffeepots known by the Turkish name *ibrik*. These are representative of the earliest known vessels for making coffee. The beverage was brought to a boil and cooled at least two or three times before being served. The folding handle made it easier to carry the *ibrik* on the back of a camel. 6 inches high, 3- to 4-cup capacity.

Primi '800

Coppia di bricchi (dal turco "ibrik") in rame; rappresentano il primo contenitore che si conosca per fare il caffè. La bevanda veniva fatta bollire e raffreddare almeno 2 o 3 volte prima di essere servita. Il manico pieghevole rendeva più facile stipare il bricco sul dorso del cammello. H. cm. 15, capacità 4 tazze.

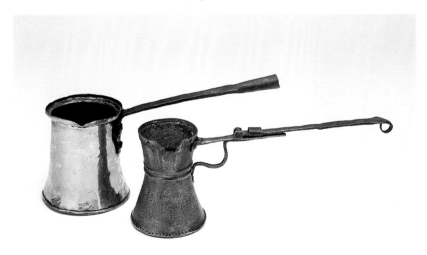

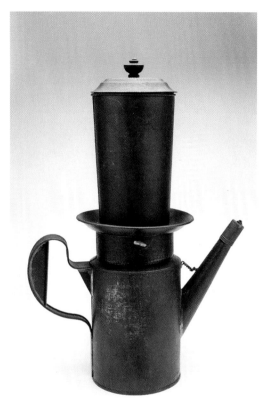

\mathscr{A}n inventive Italian drip coffeepot, made of tinplate and used in small hotels. It worked by the infusion method: turning the little valve released the hot water into the ground beans, and the beverage dripped into the lower container. 16 by 14 inches, 10-cup capacity.

Seconda metà '800

Originale modello di caffettiera filtro italiana costruita in latta stagnata, era in uso nelle locande. Il piccolo rubinetto permette di fare miscelare l'acqua calda al caffè (infusione) e poi di fare scendere nel recipiente inferiore la bevanda pronta per essere servita. Cm. 40 x 35, capacità lt. 2,5.

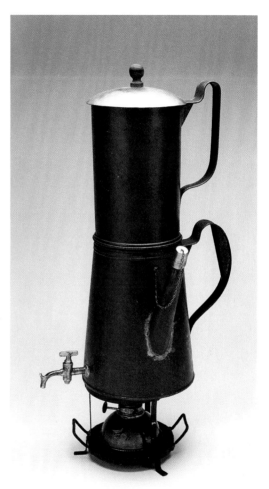

*A*n Italian tinplate drip coffeemaker, designed for small hotels. The side spigot was used to serve coffee at the bar; the large spout was used for serving at the table. The spirit lamp kept the coffee hot.

Seconda metà '800

Caffettiera filtro italiana in latta per locanda. Il rubinetto veniva usato per servire al bancone la bevanda tenuta calda con il fornetto ad alcol, mentre per servire ai tavoli si usava il grosso becco.

A Madame Bleu drip coffeepot, of enameled
iron with a little container for the hot water. 8 by 6
inches, 3- to 4-cup capacity.

'800

*Madame Bleu è il nome di questa caffettiera filtro in
ferro smaltato con piccolo contenitore per l'acqua
calda. Cm. 20 x 15, capacità lt. 1.*

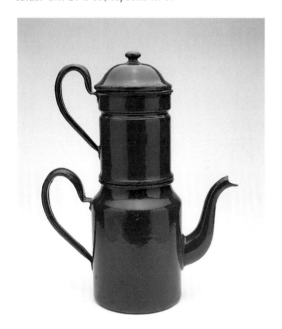

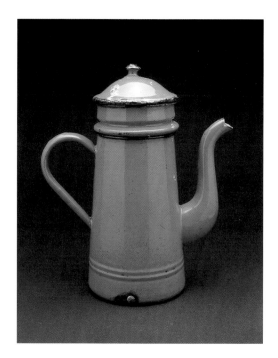

*A*nother Madame Bleu enameled-iron drip coffeepot. This type was very popular in France and Germany, and came in all sizes and in various types of metal and ceramic. Still in use in North America, it is heated on the stove. 8 by 6 inches, 4-cup capacity.

Prima metà '800

Un modello diverso di caffettiera filtro Madame Bleu in ferro smaltato e molto popolare in Francia e Germania. E' stata costruita in tutte le misure e vari tipi di metallo e ceramica. Ancora oggi è in uso nel Nord America. Riscaldamento sul fuoco. Cm. 22 x 15, capacità 4 tazzine.

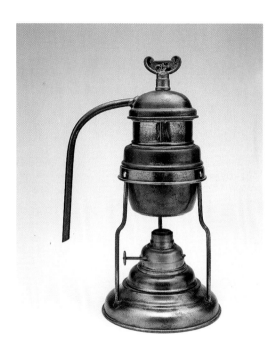

\mathcal{M}ade in Ferrara, this ingenious Aquilas brand steam-pressure coffeemaker with an alcohol stove was meant for home use. When the hot water had developed enough pressure, it was forced up a tube and through the ground beans, before coming down the tubular spout on the side. Copper and nickel-plated brass. 8 by 6 inches, 4-cup capacity.

1870

Per famiglia questa originale macchina per caffè a pressione, munita di fornello ad alcol. Al formarsi della pressione l'acqua scaldata, tramite un tubo, veniva spinta in alto dove attraversa la polvere di caffè prima di scendere dal becco laterale. Rame e ferro nichelato. Marca Aquilas, Ferrara. Cm. 22 x 15, capacità 4 tazze.

A large drip-type urn for coffeehouses or communal service, made by S.A.B. of Turin. It is hand-beaten copper, and has an indicator to show how much coffee is left in the container. Inside, a pipe coil with steam jets kept the coffee at the right temperature. It has three spigots for filling cups. 36 by 16 inches, 60-cup capacity.

Fine '800

Grande macchina a filtro per bar o comunità della S.A.B. di Torino. E' in rame martellato a mano e accessoriata con livello per controllare la quantità di bevanda nella caldaia, tenuta a temperatura grazie a una serpentina con getti di vapore, e con tre rubinetti per riempire le tazzine. Cm. 90 x 40, capacità lt. 15.

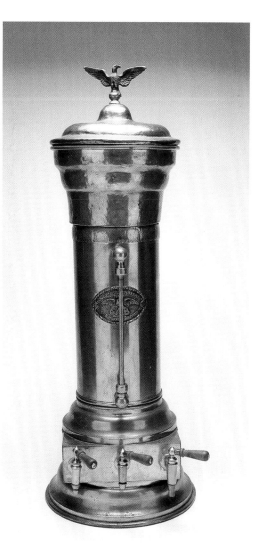

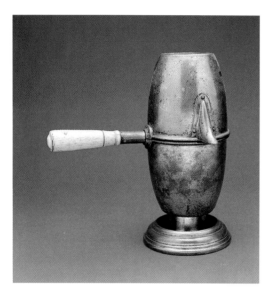

A Potsdam Reversible, a Neapolitan-style Viennese coffeemaker with an alcohol stove. This nickel silver example has a bone handle. On the base, which acted as the heater, is a support that held the pot upright until the water boiled and it was time to turn the pot upside down. 8 by 4 inches, 3-cup capacity.

1870

Potsdam: caffettiera viennese ad alcol, tipo napoletana chiamata Reversible. Esemplare in alpacca con manico in osso. Sulla base, che faceva da fornello, c'era un supporto che serviva a tenere in posizione verticale la caldaia fino al momento in cui bollendo l'acqua la si doveva capovolgere. Cm. 20 x 12, capacità 3 tazze.

1870

\mathcal{A} brass Turkish coffeepot with silver onlays and handle. This style of pot is still widely used in the Middle East. 16 by 16 inches, 6-cup capacity.

1870

Cuccuma turca in ottone con fregi e manico in argento. Tuttora di uso comune in medio oriente. Cm. 40 x 40, capacità lt. 1,5.

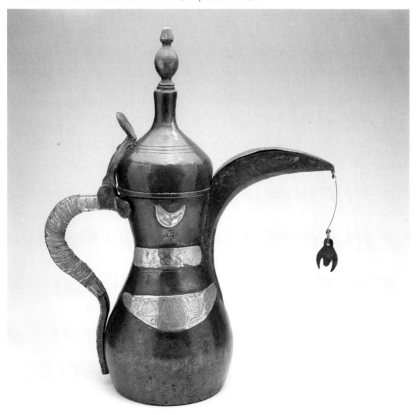

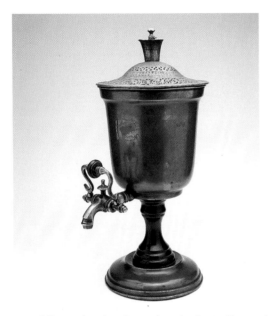

A copper Loysel with a wood base. This French coffeemaker was patented in the early 1800s by Eduard Loysel, who took the principle of the hydraulic pressure head—the pressure generated by a column of water of a certain height—and applied it to the coffee machine. Under the cover is a funnel with a telescoping tube, into which the hot water was poured. 16 by 10 inches, 4-cup capacity.

1870

Esemplare in rame con base in legno di Loysel, caffettiera francese brevettata nei primi anni dell''800 da Eduard Loysel. Egli adattò alla macchina per caffè il principio della pressione della colonna d'acqua. Sotto il coperchio mise un imbuto con tubo telescopico nel quale si versa l'acqua calda. Cm. 40 x 25, capacità lt. 1.

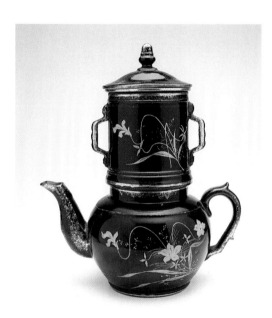

*A*n exquisite French drip coffeepot of glazed ceramic with a flower pattern in gold. These models were custom-made by skilled ceramists who drew their inspiration from Asian vases. 10 by 10 inches, 3-cup capacity.

1860

Preziosa caffettiera filtro francese in ceramica laccata con motivi floreali in oro. Questi modelli, venivano fatti su ordinazione da valenti artigiani ceramici che s'ispiravano ai vasi dell'Estremo Oriente. Cm. 25 x 25, capacità lt. 0,75.

*T*his splendid steam-pressure brewer with bronze feet, notable for its craftsmanship, was entirely handmade of copper by F. Saino of Milan in 1880. An alcohol stove heated and pressurized the water, which rose into the upper container through the ground beans. The stove was then turned down to its lowest level, and the coffee was kept hot in the tightly sealed container. 20 by 12 inches, 6-cup capacity.

1880

Bella caffettiera a pressione di particolare pregio per la manifattura artiginale. Esemplare tutto fatto a mano in rame con i supporti in bronzo. Marchio: F. Saino, Milano, 1880. L'acqua in pressione, scaldata con fornello ad alcol, saliva nel recipiente superiore attraverso la polvere di caffè. Tenendo accesa al minimo la fiammella del fornello si poteva tenere calda la bevanda nel recipiente con chiusura ermetica. Cm. 50 x 30, capacità lt 1,5. ➤

A detail of one of the finely hand-tooled bronze feet.
In primo piano uno dei supporti in bronzo finemente cesellato a mano.

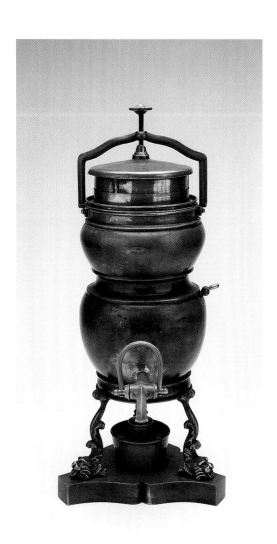

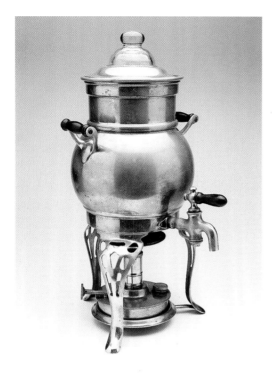

*T*his Viennese coffee-maker, known as the Balance, by A. Reiss, is made of nickel silver, glass, and wood. The boiler (for the water) and a glass container (for the coffee) are joined through a tube with a filter at its end. As the water heated up it flowed across into the glass, where it mixed with the ground coffee. A counter-weight caused the boiler to rise, letting the lid of the alcohol stove drop and put out the flame. The resulting vacuum then drew the coffee into the boiler compartment, leaving the grounds in the glass. 16 by 14 inches, 4-cup capacity.

1860

Caffettiera viennese, chiamata anche Balance, di A. Reiss.
Esemplare in alpacca, vetro e legno. Nella caldaia si metteva l'acqua e il caffè nel bic-chiere di vetro collegati tra loro da un tubo fornito di filtro all'estremità. Riscaldandosi, l'acqua travasava nel bicchiere miscelandosi alla polvere. Il contrappeso alzava la caldaia che lasciava libero il coperchio del fornello ad alcol, spegnendolo. Per effetto del vuoto creatosi la bevanda veniva risucchiata all'interno della caldaia, lasciando i fondi del caffè nel bicchiere. Cm. 40 x 35, capacità lt. 1.

*A*n American nickel-plated brass Universal coffee urn, patented in 1894. 12 by 8 inches, 3-cup capacity.

Fine '800

Caffettiera americana Universal in ottone nichelato, brevettata nel 1894. Cm. 30 x 20, capacità lt. 0,75.

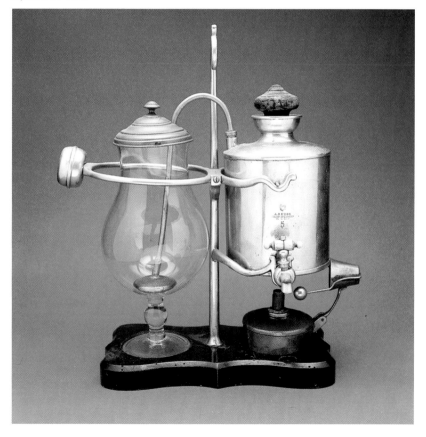

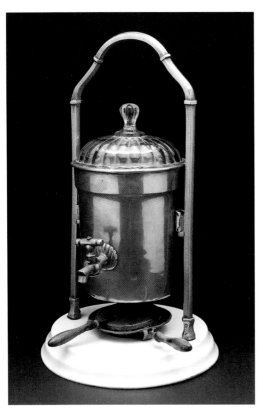

The Wien Incomparable, a Viennese steam-pressure brewer with an alcohol stove. One of the most beautiful designs of the period, it is made of brass with a ceramic base. 14 by 10 inches, 3-cup capacity.

Seconda metà '800

Wien Incomparable. Caffettiera viennese a pressione con fornello ad alcol, modello tra i più belli dell'epoca realizzato in ottone con base in ceramica. Cm. 35 x 25, capacità lt. 0,75.

*T*his Russian Reversible, of copper and bronze with an alcohol stove, worked like the Neapolitan coffeepot. Models of this type, however, were finer in both materials and detailing. 10 by 6 inches, 5-cup capacity.

Fine '800

Questa Reversible, tipo Russia, in rame e bronzo con riscaldamento ad alcol, ha funzionamento alla napoletana. Gli esemplari di questo tipo sono più ricchi sia come materiali che per le finiture. Cm. 25 x 15, capacità 5 tazze.

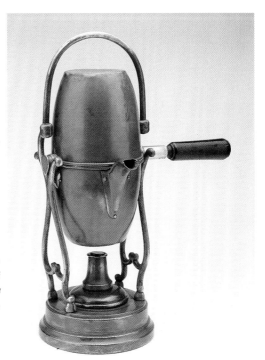

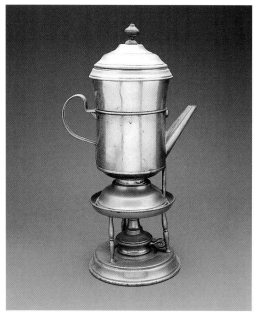

\mathcal{A} double-percolating nickel-plated brass coffeemaker heated by an alcohol stove. This model, patented by M. M. Bonillon, was very common in France and Germany in the early twentieth century. 10 by 6 inches, 5-cup capacity.

Fine '800

Caffettiera in ottone nichelato a doppia circolazione e riscaldamento ad alcol. Modello molto comune in Francia e in Germania nei primi del '900 e brevettata da M.M. Bonillon. Cm. 25 x 60, capacità 6 tazze.

\mathscr{F}rench china containers
that kept the coffee warm over
a container of hot water. The
brass boiler burned alcohol or
gas. 16 by 20 inches, 12-cup
capacity.

Fine '800

*Contenitori, di produzione
francese, in ceramica. Tenevano
caldo a bagno-maria il caffè.
Caldaia in ottone con fornello
ad alcol o gas. Cm. 40 x 50,
capacità lt. 3.*

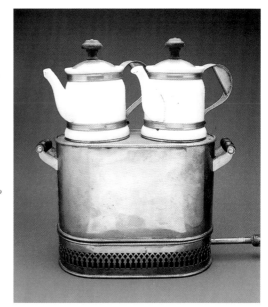

The Eicke Berlin, a complicated German coffeemaker of nickel-plated brass on a ceramic base, was perhaps the finest machine of the late nineteenth century. The alcohol stove of the steam-pressure system was shut off automatically by a balance mechanism between the boiler and the coffeepot, as the latter filled with the brewed coffee. 14 by 14 inches, 4-cup capacity.

1880

Complessa macchina per caffè tedesca "Eicke Berlin", in ottone nichelato e base in ceramica, forse la più valida costruita alla fine del secolo scorso. Sistema a pressione alimentato da alcol e spegnimento automatico grazie al meccanismo a bilancia tra la caldaia e la cuccuma che riceve il caffè pronto. Cm. 35 x 35, capacità lt. 1.

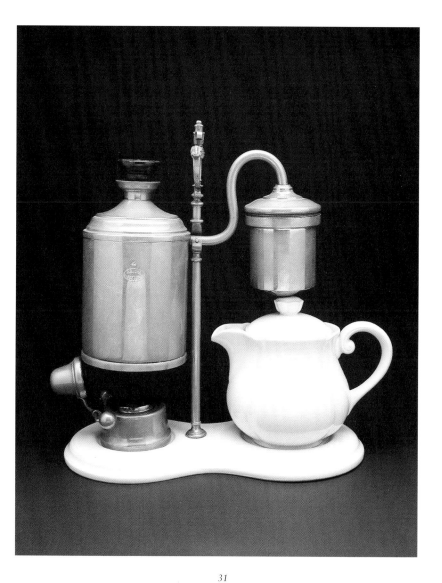

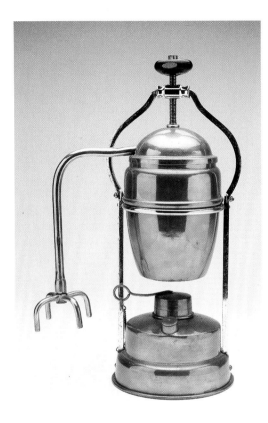

\mathcal{T}his egg-shaped copper and brass coffeemaker has four spouts for as many cups. An alcohol-burning steam-pressure brewer, it was made by Cozzante of Turin. 12 by 8 inches, 4-cup capacity.

Fine '800

Forma ovoidale per questa caffettiera in rame e ottone con quattro beccucci per altrettante tazzine, marca Cozzante di Torino. Sistema a pressione con funzionamento ad alcol. Cm. 30 x 20, capacità 4 tazze.

\mathcal{A}n alcohol-burning urn for Turkish coffee. Manufactured in England and France under the Cafeta brand, it came in a variety of metals but always had the same shape. A whistling valve at the top, activated by the boiling water, signaled that the coffee was ready. 10 by 7 inches, 2-cup capacity.

Fine '800

Caffettiera ad alcol per preparare il caffè "turco". Fabbricata in Inghilterra e in Francia col marchio "Cafeta" era di metalli diversi ma aveva sempre la stessa forma. Una volta, azionata dall'acqua in ebollizione, con un fischio segnalava che la bevanda era pronta. Cm. 25 x 18, capacità lt. 0,5.

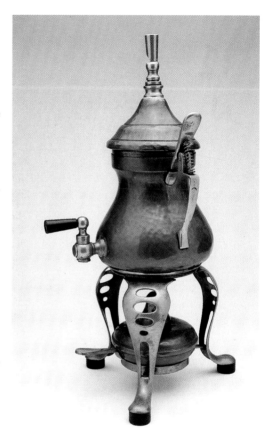

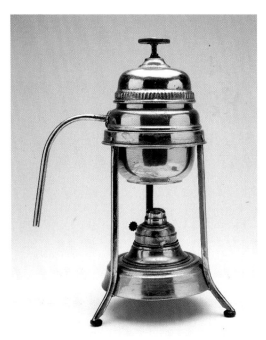

A steam-pressure brewer made of copper and nickel-plated iron, with an alcohol stove. The brand is Santini of Ferrara. 10 by 8 inches, 4-cup capacity.

Fine '800

Caffettiera sistema a pressione in rame e ferro nichelato con fornello ad alcol, marca Santini di Ferrara. Cm. 25 x 20, capacità 4 tazze.

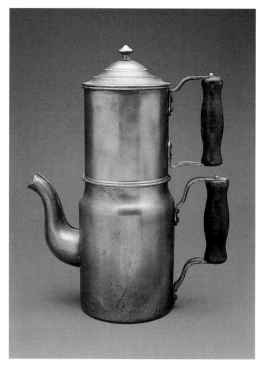

A classic copper drip coffeepot for home use. During this era, Italy saw the birth of an industry that would soon achieve worldwide eminence in the creation of coffee machines. 11 by 8 inches, 3-cup capacity.

Fine '800

Classica caffettiera filtro in rame, uso famiglia. In quest'epoca in Italia comincia l'era dell'industria che ben presto occuperà un posto preminente nella creazione di macchine per fare il caffè. Cm. 28 x 20, capacità lt. 0,75.

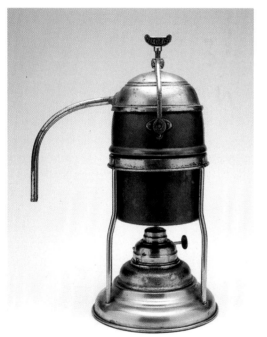

*A*n alcohol-burning steam-pressure brewer from Italy, made of copper and nickel-plated iron. The brand is Aquilas of Ferrara. 11 by 8 inches, 5-cup capacity.

Fine '800

Modello italiano a pressione e funzionamento ad alcol, marca Aquilas di Ferrara. Rame e ferro nichelato. Cm. 28 x 20, capacità 5 tazze.

\mathcal{A} Russian Reversible in
nickel-plated brass. This
Neapolitan-style coffeemaker
used the drip method. The
alcohol stove is inside the
matching base of incised cast
metal. 12 by 8 inches, 4-cup
capacity.

Primi '900

Caffettiera russa in ottone
nichelato, tipo napoletana con
sistema a caduta. L'apposito
piedestallo, fuso e inciso, con-
tiene il fornello ad alcol. Cm.
30 x 20, capacità 4 tazze.

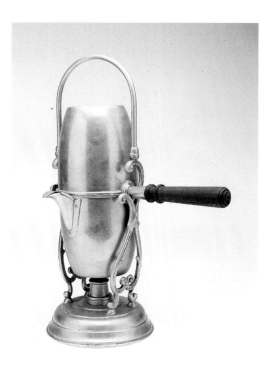

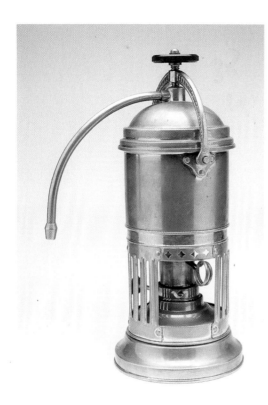

Simple lines and a long spout are the outstanding features of this Stella nickel-plated brass coffeemaker, made in Ferrara. This steam-pressure machine with an alcohol stove was widely used in Italy through the 1920s. 12 by 7 inches, 4-cup capacity.

Primi '900

Linea semplice e un lungo becco per la caffettiera Stella in ottone nichelato, fabbricata a Ferrara. Macchina per caffè molto in uso in Italia fino agli anni '20. Sistema a pressione con fornello ad alcol. Cm. 30 x 18, capacità 4 tazze.

A Viennese brass coffeemaker, patented by Josef Denk. One of the most popular models in Austria, Germany, and England, it used an alcohol-burning steam-pressure system and came in a variety of sizes. 13 by 11 inches, 3-cup capacity.

Primi '900

Caffettiera Viennese in ottone, brevetto Josef Denk. Sistema a pressione con funzionamento ad alcol per questo modello tra i più popolari in Austria, Germania e Inghilterra. Era costruito in misure diverse. Cm. 33 x 28, capacità lt. 0,75.

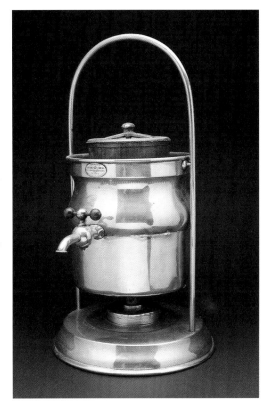

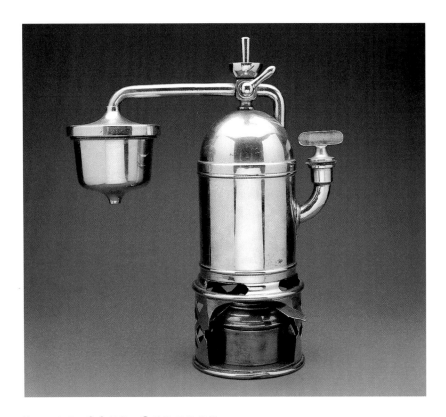

*A*n alcohol-burning steam-pressure brewer from Italy. In many machines of the era the filter was kept separate from the boiler so as not to overheat the ground coffee. 14 by 10 inches, 5-cup capacity.

Primi '900

Caffettiera italiana a pressione e riscaldamento ad alcol. In molte macchine costruite in quel periodo il filtro era staccato dalla caldaia, ciò per non surriscaldare la polvere di caffè. Cm. 35 x 25, capacità 5 tazze.

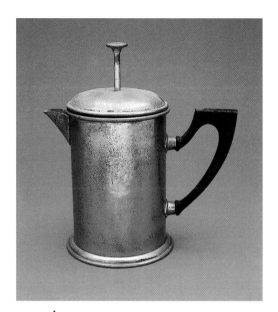

\mathscr{A} little nickel-plated brass coffeepot that used
the plunger method. Water and ground coffee were
combined in the container; then the rod in the cover,
which has a strainer attached to its lower end, was
used to push the grounds to the bottom. 6 by 4
inches, 4-cup capacity.

Primi '900

*Piccola caffettiera in ottone nichelato con sistema a
pompa. Si mettevano acqua e caffè nel recipiente poi,
pressando il filtro attaccato all'asta sul coperchio, si
faceva venire in superficie la bevanda senza i fondi.
Cm. 15 x 10, capacità 4 tazze.*

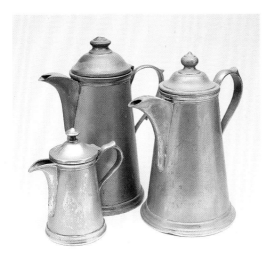

\mathscr{A} group of nickel-plated brass serving pots in different sizes. These were used not to make coffee but rather to keep it hot.

Primi '900

Gruppo di cuccume di varie misure in ottone nichelato. Servivano non tanto per fare il caffè ma per contenerlo e tenerlo caldo.

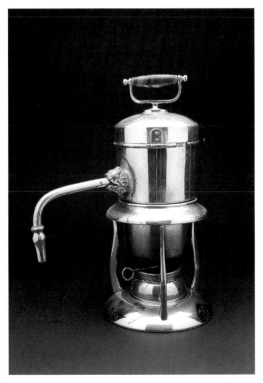

*A*n Italian nickel-plated brass coffeemaker with beautiful detailing. It used steam pressure and an alcohol stove. An elegantly carved fish head supports the coffee spout. 12 by 8 inches, 5-cup capacity.

Primi '900

Pregevole lavorazione per questa caffettiera italiana in ottone nichelato, sistema a pressione con funzionamento ad alcol. Una testa di pesce finemente cesellata sorregge il becco d'uscita del caffè. Cm. 30 x 20, capacità 5 tazze.

\mathcal{A} vacuum coffeemaker with glass containers, of a type that had been made in England and Germany since about 1850. It was in that era that a woman named Madame Vassieux took an interest in these machines and patented a version with a valve and spout in the lower container to pour the coffee. Today, the Cona is still the most popular version. The photograph shows a handsome example made in England for the Milanese company Moka Efti. 18 by 8 inches, 6-cup capacity.

Primi '900

Macchina per caffe Vacuum (sottovuoto) a sfera di vetro del tipo già costruito in Inghilterra e in Germania verso il 1850. In quell'epoca anche una signora francese, Madame Vassieux, si cimentò con queste macchine e ne brevettò un tipo fornito di rubinetto per prelevare il caffè, sistemato nel globo inferiore. La più popolare è ancora oggi la Cona, nella foto un bell'esemplare costruito in Inghilterra per conto della ditta Moka Efti di Milano. Cm. 45 x 20, capacità 6 tazze.

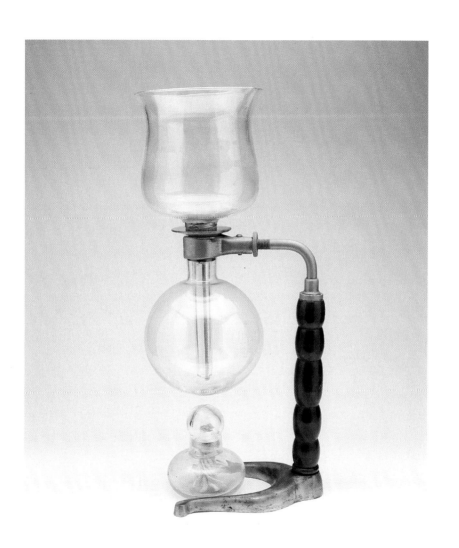

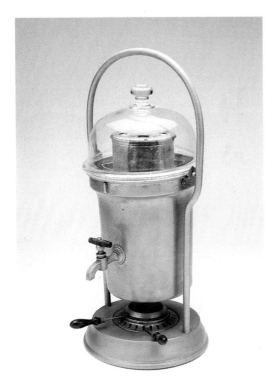

A Viennese nickel-plated brass model for large families or small hotels. It used the steam-pressure method; the alcohol lamp served both to brew the coffee and to keep it hot afterward. 24 by 14 inches, 8-cup capacity.

Prima '900

Per famiglie numerose o locande questo modello viennese in ottone nichelato. Sistema a pressione con fornello ad alcol che poteva essere usato sia per preparare la bevanda che per tenerla calda. Cm. 60 x 35, capacità lt. 2.

A steam-pressure brewer
of elegant and original design,
heated with alcohol and outfit-
ted with a whistle that signaled
when the water was hot.
Shutting a valve forced the
pressurized water through the
ground coffee in the filter on
the side, and from there the cof-
fee dripped down into a brass
serving pot. 10 by 8 inches,
4-cup capacity.

Prima '900

*Di linea elegante e originale
questa caffettiera a pressione,
riscaldata ad alcol e munita di
fischietto avvisatore per quando
l'acqua è calda. Chiudendo l'ap-
posito rubinetto l'acqua in pres-
sione passava nel filtro laterale
contenente il caffè per poi
cadere in una cuccuma d'ottone.
Cm. 25 x 20, capacità 4 tazze.*

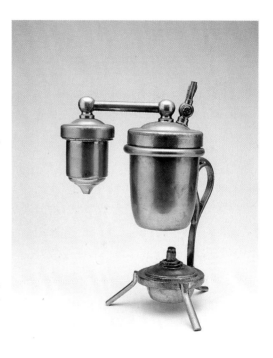

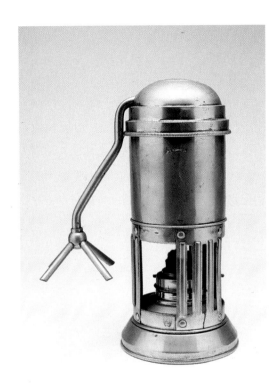

 Vittoria Sport cof-
feemaker made of nickel-plated
brass, with an inventive spout
and an alcohol-burning steam-
pressure system. This was one
of the most widely used
machines in Italy just after the
turn of the century. 12 by 8
inches, 4-cup capacity.

Primi '900

*Caffettiera Vittoria Sport in
ottone nichelato con originale
beccuccio; era una delle mac-
chine più usate in Italia ai
primi del nostro secolo. Sistema
a pressione, funzionamento ad
alcol. Cm. 30 x 20, capacità 4
tazze.*

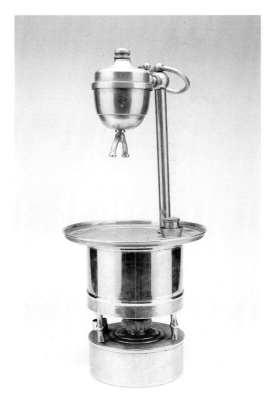

The French S.G.D.G. shown here is made entirely of nickel-plated brass, and could make two cups of coffee at a time until the water ran out. It has an alcohol-burning steam-pressure system and a refillable filter holder. 16 by 8 inches, 8-cup capacity.

Primi '900

La francese S.G.D.G qui fotografata è tutta in ottone nichelato e serviva a preparare due caffè per volta fino all'esaurimento dell'acqua. Funzionamento ad alcol con sistema a pressione e portafiltro ricaricabile. Cm. 40 x 20, capacità 8 tazze.

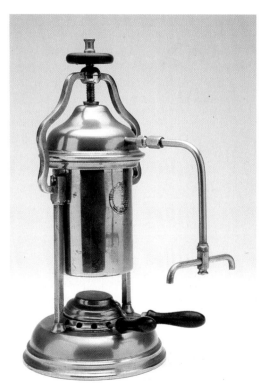

\mathcal{J}his small nickel-plated brass coffee machine, the Ideal, was made by Pavoni. It has a steam-pressure system with an alcohol stove. 8 by 7 inches, 2-cup capacity.

Primi '900

Costruita dalla ditta Pavoni questa piccola macchina per caffè Ideal in ottone nichelato. Sistema a pressione con fornello ad alcol. Cm. 20 x 18, capacità 2 tazze.

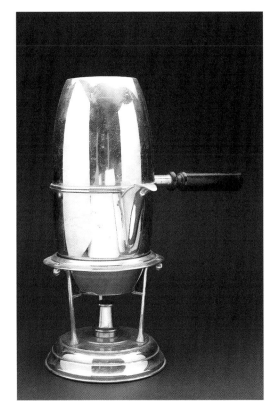

\mathcal{T}his flip-drip Neapolitan-type coffeemaker is made of nickel-plated brass and was considered a deluxe model in its day. It is an alcohol-heated W.M.I. brand. 14 by 8 inches, 8-cup capacity.

Primi '900

In ottone nichelato questa macchina per caffè da capovolgere, tipo napoletana. A suo tempo era considerata di lusso. Marchio W.M.I. Riscaldamento ad alcol. Cm. 35 x 20, capacità 8 tazze.

\mathcal{D}ated December 28, 1916, this American Viko percolator from the A.G.N. Company is made of Anticorodal, a special kind of aluminum, and represents a type of coffeemaker still widely used in the United States today. 10 by 10 inches, 4-cup capacity.

1916

Datata 28 dicembre 1916 questa caffettiera americana Viko A.G.N. Company in alluminio speciale Anticorodal, modello ancora oggi molto usato in America. Sistema a circolazione. Cm. 25 x 25, capacità lt. 1.

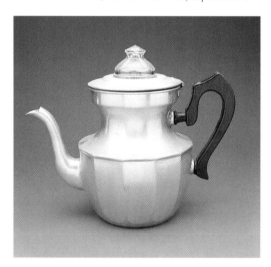

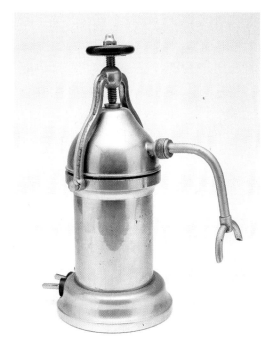

*T*his Snider, an Italian machine designed for the home, is made of nickel-plated brass. It was easy to use, and has an electric heater with graphite elements. 8 by 6 inches, 2-cup capacity.

Anni '20

Macchina italiana Snider per famiglia, in ottone nichelato. Di facile uso, aveva riscaldamento elettrico a grafite. Cm. 20 x 15, capacità 2 tazze.

*T*hree little bronze statues of the type used to embell-
ish coffee-bar machines until the late 1930s. After casting,
they were finished by hand tooling. The brands are
Carimali, Lombarda, and Bezzera.

Anni '20

Tre piccole statue in bronzo che fino alla metà degli anni
'30 venivano messe sopra le macchine per caffè da bar, per
arricchirle. Dopo la fusione venivano rifinite a mano con
lavoro di cesello. La Carimali, la Lombarda, la Bezzera. ➤

A group of ornamental statuettes for coffee
machines: Victoria Arduino, San Marco, and Universal.

Gruppo di statuette ornamentali per macchine da caffè.
La Victoria Arduino, la San Marco e l'Universal.

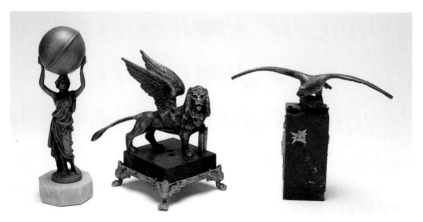

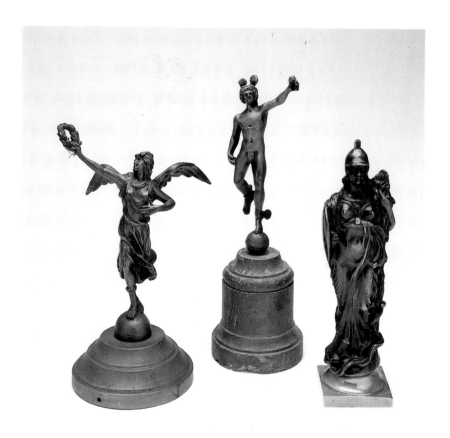

\mathcal{A} large espresso machine built by Pavoni in the 1920s. This is thought to be not only the first such machine to sell widely, but also the one that popularized the custom of drinking Italian-style espresso in coffee bars, first in Europe, and later throughout the world. The photo shows two deluxe brewing and serving mechanisms, called groups, made of copper and bronze. Note the enamel work, the imitation gold leaves on the dome, and the elegant central nameplate. 40 by 28 inches, serving 150 to 200 cups of coffee an hour.

Anni '20

Capace macchina da bar per caffè "espresso" costruita negli anni '20 dalla ditta Pavoni. Viene considerata non solo la prima commercializzata in grande serie ma anche quella che ha fatto diffondere in Europa e poi in tutto il mondo di bere al bar il caffè "espresso" all'italiana. Nella foto, due gruppi tipo lusso in rame e bronzo. Da notare gli smalti, le fronde in similoro sopra la cupola e il bel marchio centrale. Cm. 100 x 70, poteva servire 150-200 caffè all'ora. ➢

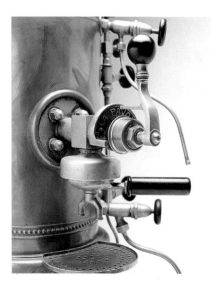

A detail of one of the brewing and serving mechanisms of the Pavoni model.
In primo piano il gruppo acqua-vapore-scarico del modello Pavoni.

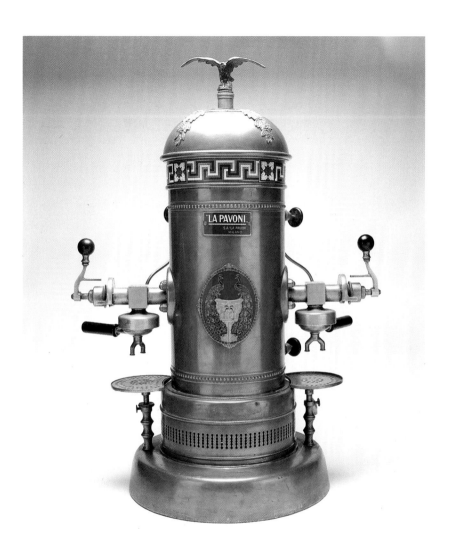

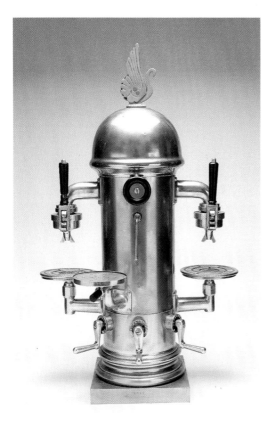

A unique bar-sized Italian cast-bronze Snider machine was the first "instant" electric machine to be produced without a central boiler. Since each brewing-serving mechanism has its own small boiler chamber for steam and hot water, there was no need to keep the entire machine constantly under pressure, and water could be heated up to make coffee within minutes. 36 by 24 inches.

Anni '20

Macchina da bar italiana Snider tipo istantaneo, in unica fusione in bronzo, la prima elettrica costruita senza caldaia centrale. Ogni gruppo, aveva una caldaietta per il vapore e l'acqua calda: ciò rendeva inutile tenere sempre in pressione la macchina perchè in pochi minuti si scaldava e faceva il caffè. Cm. 90 x 60.

\mathcal{A} fine Italian machine of
nickel-plated brass, with bone
handles and a circular base to
hold the cups. Made by the
S.I.M.E.R.A.C. company, this is
a steam-pressure brewer that
was run by electricity. Turning
the little valves on top distrib-
uted water from the central
boiler to the filter holders con-
taining the ground coffee. 14 by
14 inches, 8-cup capacity.

Anni '20

*Bella macchina italiana in
ottone nichelato, manici in osso
e base circolare appoggiatazza,
della ditta S.I.M.E.R.A.C.
Sistema a pressione, alimen-
tazione elettrica. Tramite i piccoli rubinetti in alto, l'acqua sotto pressione dalla cal-
daia centrale veniva distribuita nei portafiltri esterni contenenti la polvere di caffè.
Cm. 35 x 35, capacità 8 tazze.*

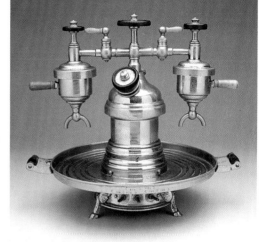

\mathscr{A} complicated electric steam-pressure machine by Velox of Ferrara, complete with a stand for the machine and shelves for the serving pots. The top with the coffee filter could be removed and replaced with attachments for heating milk or making tea. 9 by 6 inches, 4-cup capacity.

Anni '20

Complessa macchina per caffè elettrica, a pressione, della marca Velox di Ferrara, arricchita con sottomacchina e supporti per le cuccume. Togliendo la parte superiore con il filtro per il caffè si potevano inserire ricambi adatti a scaldare il latte o a fare il tè. Cm. 23 x 15, capacità 4 tazze.

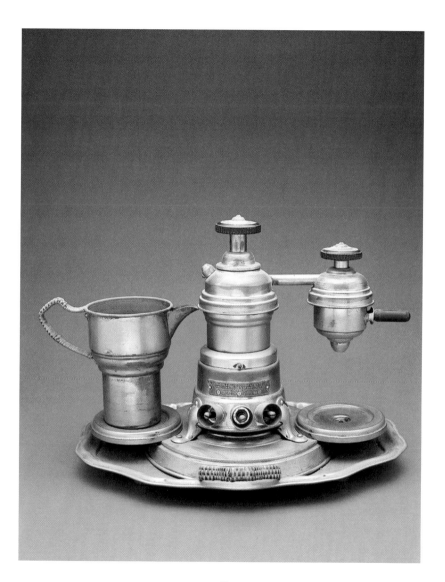

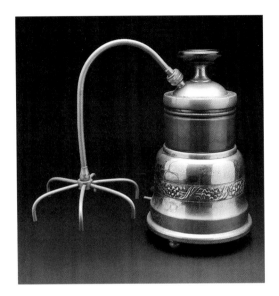

\mathcal{F}rom Universal of Milan, this capacious elec-
tric coffeemaker is made of copper and used the
steam-pressure method. The inventive spider-leg noz-
zle arrangement allowed six cups to be filled at the
same time. 14 by 14 inches, 6-cup capacity.

Anni '20

Della ditta Universal di Milano questa capiente
macchina per caffè elettrica in rame, sistema a pres-
sione. L'originale becco a ragno permetteva di riem-
pire contemporaneamente sei tazze. Cm. 35 x 35,
capacità 6 tazze.

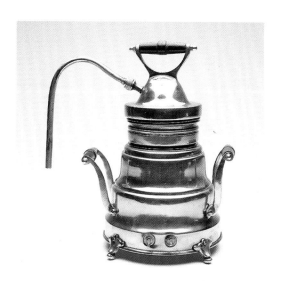

\mathscr{A} very graceful Italian electric coffeemaker of copper and nickel-plated brass. It was usually accompanied by a serving pot. 14 by 12 inches, 6 cup capacity.

Anni '20

Di linea molto graziosa questa caffettiera elettrica, di fabbricazione italiana, in rame e ottone nichelato. Di solito era accompagnata da una cuccuma per servire il caffè. Cm. 35 x 30, capacità 6 tazze.

\mathscr{A}n electric steam-pressure brewer from Amer of Turin. One valve released the water from the reservoir into the boiler below; another regulated the flow to the filter containing the coffee. 16 by 12 inches.

Anni '20

Macchina elettrica, a pressione, della ditta Amer di Torino. Un rubinetto faceva passare l'acqua dal serbatoio nella caldaia sottostante. Un altro rubinetto ne regolava il flusso al filtro col caffè. Cm. 40 x 30.

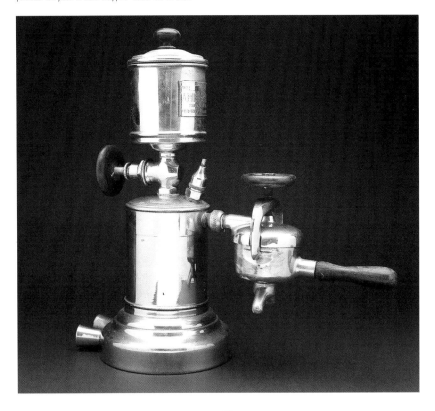

A Lampo brand home coffeemaker made in Pavia in the 1920s. The material is cast brass, and the machine worked by the electric steam-pressure method. 10 by 8 inches, 4-cup capacity.

Anni '20

Caffettiera per famiglia marca Lampo costruita a Pavia negli anni '20. Fusione in ottone, alimentazione elettrica, sistema a pressione. Cm. 25 x 20, capacità 4 tazze.

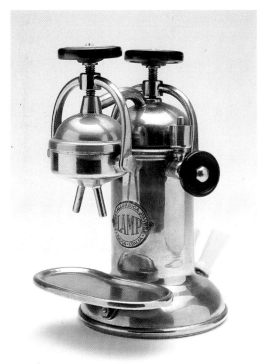

*T*his very elaborate nickel-plated brass
machine, with elegant lines reminiscent of a
coffee-bar model, came from the Eterna company
of Pavia. It is electric, with a whistle to signal
that the machine has reached working pressure,
and two valves on the spouts to serve the coffee.
12 by 12 inches, 4-cup capacity.

Anni '20

*Questa macchina in ottone nichelato, molto elab-
orata e di linea elegante assai simile ai modelli
per bar, è della ditta Eterna di Pavia. Funziona-
mento elettrico e valvola a fischietto per segna-
lare la macchina in pressione. Due rubinetti sui
becchi per distribuire il caffè. Cm. 30 x 30,
capacità 4 tazze.*

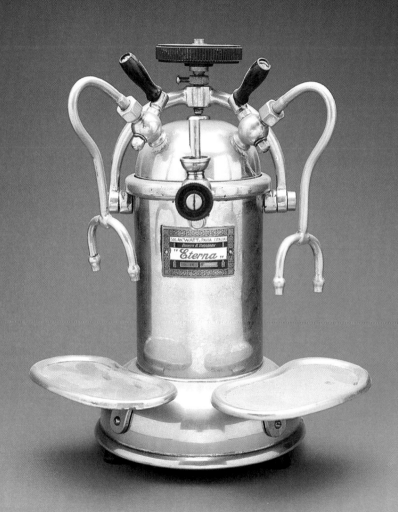

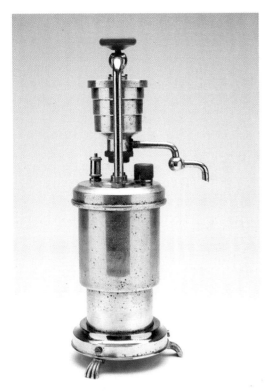

This electric Femoka brand machine, from Paris, used a unique variation on the steam-pressure system. Pressurized water flowed through the side tubes into the coffee filter on top of the boiler, then the brewed coffee poured through the spout into the pot. 14 by 7 inches, 6-cup capacity.

Anni '20

Originale elaborazione del sistema a pressione per questa macchina per caffè elettrica marca "Femoka", di Parigi. Il filtro con la polvere, che è posto sopra la caldaia, riceveva l'acqua in pressione attraverso i tubi laterali e quindi dal beccuccio la bevanda pronta scendeva nella cuccuma. Cm. 36 x 18, capacità 6 tazze.

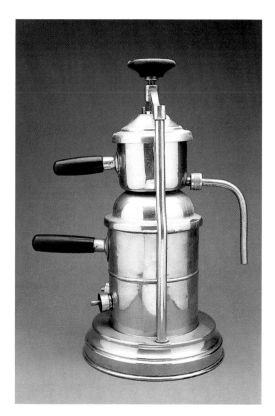

A large electric
steam-pressure brewer, made
in Italy of nickel-plated
brass. The U-bar with the
handle on top served to keep
the coffeemaker tightly
closed. Turbich B.T.D.
brand. 16 by 8 inches, 10-
cup capacity.

Anni '20

*Capace caffettiera elettrica a
pressione, di produzione
italiana, in ottone nichelato.
Il cavallotto con manopola
in alto serviva a tenere tutto
chiuso ermeticamente. Marca
Turbich B.T.D. Cm. 40 x 20,
capacità 10 tazze.*

Made by the German company Krups, this sumptuous machine, complete with an alcohol stove, is made of silver with an ivory spigot handle. 12 by 10 inches, 8-cup capacity.

Anni '20

Costruita dalla ditta tedesca Krups, questa lussuosa macchina per caffè, con fornello ad alcol, è in argento col manico del rubinetto in avorio. Cm. 30 x 25, capacità 8 tazze.

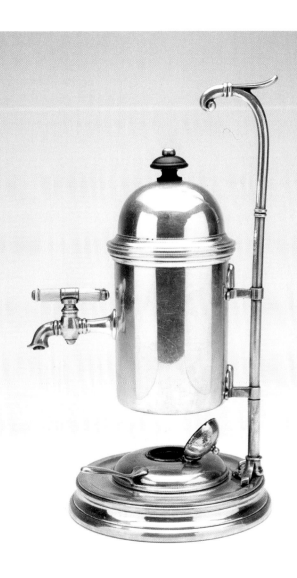

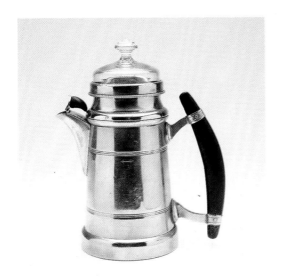

\mathscr{A} G.B.N. Bavaria brand stove-top machine
that continuously percolated water through the coffee.
It is made of nickel-plated brass, with a bone handle
and spout cover. 8 by 8 inches, 6-cup capacity.

Anni '20

*Macchina da fuoco, con circolazione continua del-
l'acqua attraverso il caffè. Ottone nichelato, manico
e copribeccuccio in osso. Marca G.B.N. Bavaria.
Cm. 22 x 20, capacità 6 tazze.*

*A*n attractively shaped French coffeepot made of nickel-plated brass. It was heated on the stove; when the water boiled, it passed through the tube in the handle into the coffee filter, and the coffee dripped into the container in the middle. 16 by 10 inches, 6-cup capacity.

Anni '20

Bella forma di caffettiera francese in ottone nichelato. Si scaldava sul fornello e quando l'acqua bolliva passava attraverso il tubo del manico, nel filtro del caffè, per poi ricadere nel recipiente di mezzo. Cm. 40 x 25, capacità 6 tazze.

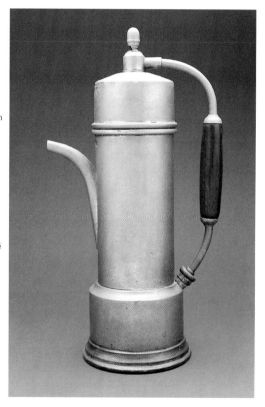

\mathcal{A} delightful air-pressure brewer from A. U.
Jvonne of Milan, made of nickel-plated brass. The
ground coffee was placed in the upper container
and compressed with a filter. Hot water was added
and forced through the coffee using the little
pump on the base, yielding a creamy, fragrant bev-
erage. 14 by 8 inches, 4-cup capacity.

Anni '20

*Deliziosa macchina a pressione d'aria, marca A.U.
Jvonne di Milano. Ottone nichelato. La polvere di
caffè veniva messa nel recipiente superiore nel
quale un filtro la pressava. Dopo aver aggiunto
l'acqua calda, questa veniva fatta uscire azionando
la piccola pompa fissata alla base ottenendo così
un caffè cremoso e profumato. Cm. 32 x 22,
capacità 4 tazze.*

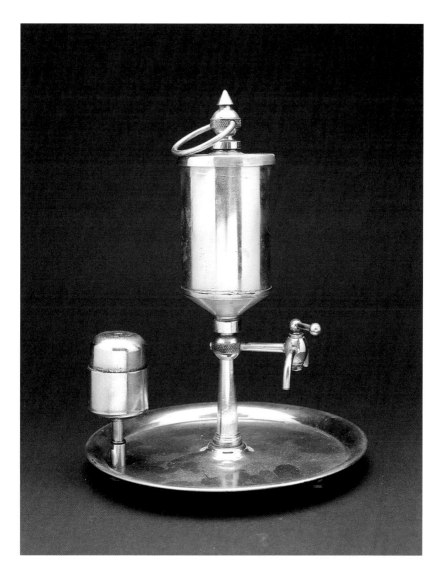

A Zenit machine from
Italy, made of nickel-plated
brass with a glass lid that
allowed the coffee to be
watched as it brewed. It used
the electric heater, steam-
pressure method. 12 by 8
inches, 3- to 4-cup capacity.

Anni '20

*Macchina Zenit, Italia, in
ottone nichelato e con coper-
chio di cristallo che consente di
vedere il caffè in preparazione.
Riscaldamento elettrico, sis-
tema a pressione. Cm. 30 x 22,
capacità 3–4 tazze.*

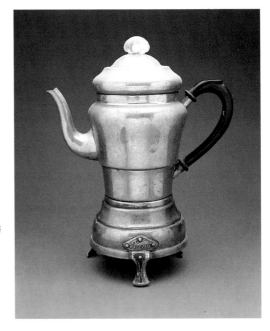

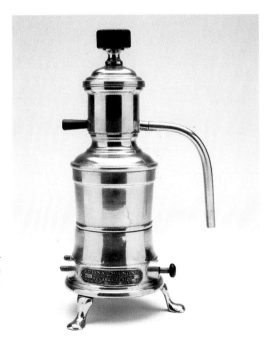

A very widely used type
of steam-pressure brewer from
Diana-Mignon of Novara. The
electric heater automatically
turned off as soon as the
brewed coffee had finished ris-
ing into the upper chamber.
11 by 8 inches, 5-cup capacity.

Anni '20

Modello molto comune di
macchina a pressione. Marca
Diana-Mignon di Novara.
Riscaldamento elettrico con sis-
tema automatico di stacco della
corrente quando il caffè pronto
finisce di salire nel recipiente
superiore e fuoriesce. Cm. 28 x
22, capacità 5 tazze.

A distinctive nickel-plated brass machine very much in the style of its time. The manufacturer name, Victoria Arduino of Turin, appears clearly on the splendid enameled bronze nameplate. When the steam had reached the right pressure, closing the valve on top forced the hot water through the coffee. 12 by 10 inches, 6-cup capacity.

Anni '20

Caratteristica macchina in ottone nichelato costruita nello stile dell'epoca. La marca Victoria Arduino, di Torino, è evidenziata dalla bella targa in bronzo smaltato. Quando si formava la pressione giusta del vapore, chiudendo il rubinetto superiore, l'acqua calda veniva spinta fuori attraverso il caffè. Cm. 30 x 25, capacità 6 tazze.

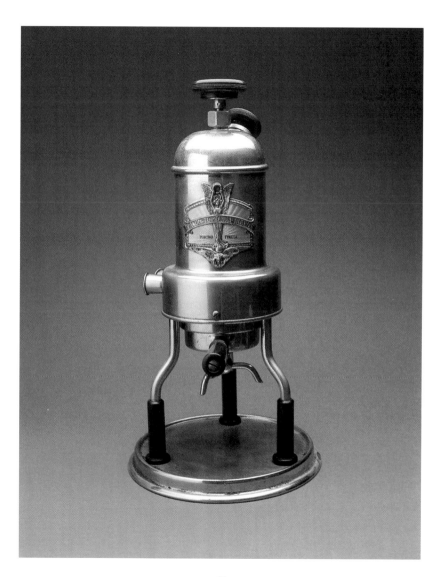

\mathcal{A} pair of coffeemakers for the table, widely used in restaurants (particularly in France) and on ships. Coffee was compressed with a filter in the top part, and when hot water was added, the brewed beverage dripped directly into the glass cup below. These little brewers came in various metals and in various sizes.

Anni '20

Coppia di caffettiere da tavola molto usate nei ristoranti, specialmente quelli francesi, e sulle navi. Nella parte superiore si metteva il caffè pressandolo con un filtro e si aggiungeva l'acqua calda, la bevanda passava direttamente nel bicchiere sottostante. Queste macchine venivano costruite in metalli e capacità diversi.

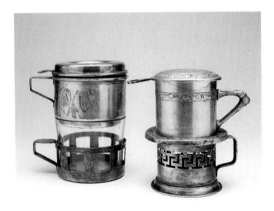

*A*n Italian aluminum coffeemaker, Rapida Espress brand, that
used a bar-type water-and-steam system. When the water boiled,
ground coffee was put into the filter, and the smaller, upper handle
was turned to send first water, then steam (for more pressure)
through the filter. 14 by 12 inches, 10-cup capacity.

Anni '30

*Caffettiera italiana in alluminio marca Rapida Espress. Sistema
acqua-vapore tipo bar. Quando l'acqua bolliva si aggiungeva la pol-
vere nel filtro laterale e si manovrava la piccola manopola superiore
per fare passare prima acqua e poi vapore per fare più pressione.
Cm. 35 x 30, capacità 10 tazze.*

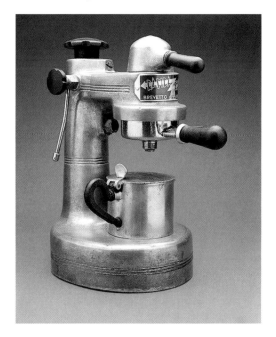

*U*niversal brand American coffee service, made of beaten brass. The service consists of a coffee urn, milk pitcher, and sugar bowl. The urn is an electric percolater.

Anni '20

Servizio americano, marca Universal, in ottone martellato. E' composto da caffettiera, bricco per il latte e zuccheriera. La macchina funzionava elettricamente con sistema a circolazione. Cm. 38 x 35, capacità 12 tazze.

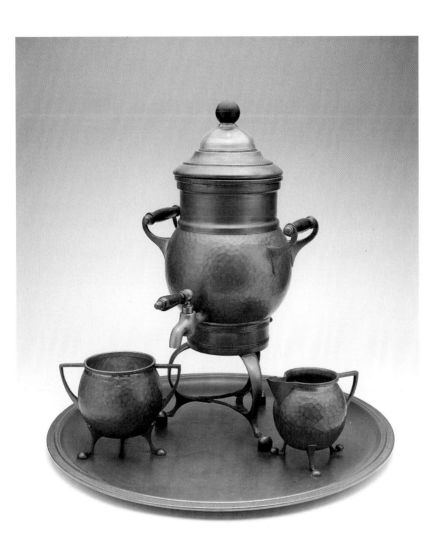

\mathcal{G}erman-made brass perco-
lator by Graetzor. The electric
heater shut off automatically.
Note the stylized shape, very
similar to a teapot. 11 by 15
inches, 12-cup capacity.

Anni '30

*Macchina in ottone di fabbri-
cazione tedesca, marca Graetzor,
con sistema a circolazione, fun-
zionamento elettrico e spegni-
mento automatico. Da notare la
forma a coppa stilizzata, assai
simile a una teiera. Cm. 28 x 30,
capacità 12 tazze.*

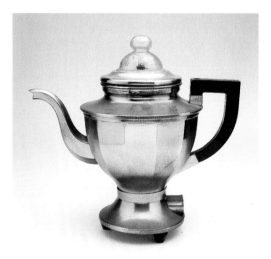

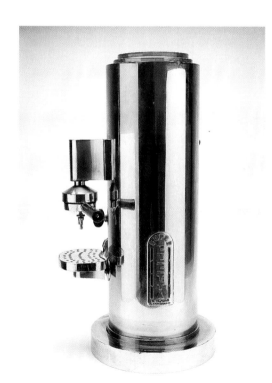

*A*n "instant" type of coffee-bar machine, this Eletta brand, from Milan, is made of chrome-plated brass. Note the change in style since the twenties: it's sleeker. 28 by 14 inches.

Anni '30

Macchina da bar tipo istantaneo, in ottone cromato. Marca Eletta, di Milano. Da notare il cambiamento dello stile dagli anni '20: piu liscio. Cm. 70 x 35.

\mathcal{A} typical example of an electric coffee machine with a quick-fastening cover. This Iloger brand from France is made of aluminum and ran on electricity. The coffee poured from four spouts when the corresponding valves were opened. 5 by 7 inches, 4-cup capacity.

Anni '20

Caratteristico modello di macchina elettrica per caffè con aggancio rapido del coperchio. Marca Iloger, Francia. Costruita in alluminio funzionava a elettricità. Il caffè veniva distribuito dai quattro beccucci azionando gli appositi rubinetti. Cm. 13 x 18, capacità 4 tazze.

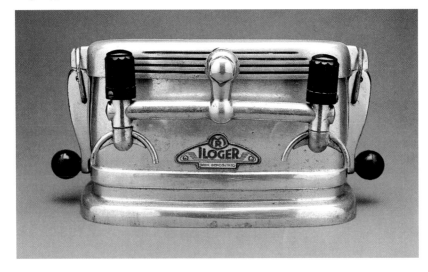

\mathcal{T}his vacuum-system cof-
feemaker with its glass vessels
bears a considerable resem-
blance to a still. It includes an
alcohol stove and a distinctive,
stylish metal support. 13 by 12
inches, 6-cup capacity.

Anni '30

*Ricorda molto un alambicco
questa macchina a globi di
vetro per fare il caffè col sis-
tema sottovuoto. Fornello ad
alcol con originale e stilizzato
supporto in metallo. Cm. 33 x
30, capacità 6 tazze.*

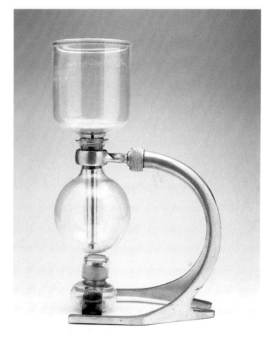

\mathcal{A} combination coffeemaker and alarm clock from Gaude of Turin. Completely automatic, the machine switched itself on according to the time set on the clock, causing pressure to build up and force brewed coffee directly into the cup. The weight of the filled cup actuated a balance mechanism that set off the alarm. Machines of this kind had been made since the turn of the century, but enjoyed little success. 12 by 13 inches, 1-cup capacity.

Anni '30

Macchina-sveglia per caffè della ditta Gaude di Torino. Completamente automatica funzionava all'ora voluta puntando l'orologio; si accendeva, entrava in pressione facendo poi scendere la bevanda direttamente nella tazza. Questa, appesantendosi, azionava un meccanismo a bilancia che faceva trillare la sveglia. Le prime macchine di questo tipo erano state costruite all'inizio del secolo, ma con poco successo. Cm. 30 x 34, capacità 1 tazza.

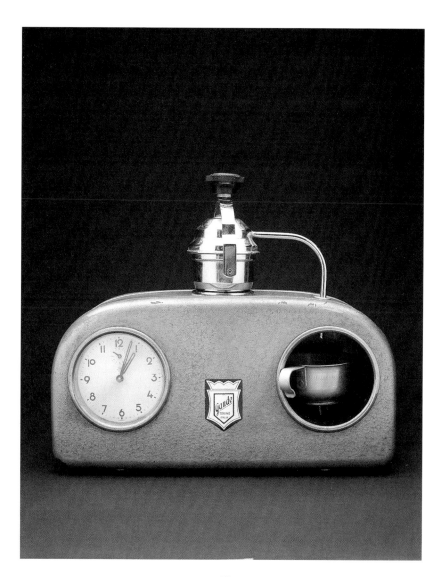

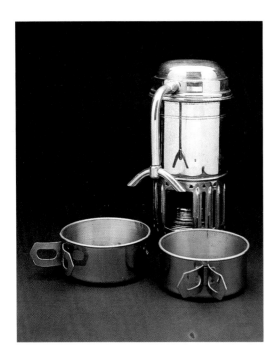

A small travel coffeemaker of nickel-plated
brass with an alcohol stove. The cups were stored
under the base. The brand is Adele-Aquilas from
Ferrara. 6 by 4 inches, 2-cup capacity.

Anni '30
*Piccola macchina da viaggio in ottone nichelato,
con fornello ad alcol. Le tazzine venivano conser-
vate sotto la base. Marca Adele-Aquilas di Ferrara.
Cm. 15 x 10, capacità 2 tazze.*

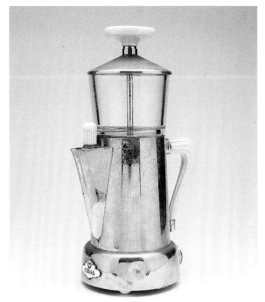

A nickel-plated brass machine, Turca-Newlux brand, from Milan. Water was placed in the lower container, and coffee in the filter in the middle. The valve on the spout was closed, and the hot water was forced into the glass reservoir on top, then was drawn back down into the lower container by vacuum action. 11 by 8 inches, 4-cup capacity.

Anni '30

Macchina in ottone nichelato, marca Turca-Newlux di Milano. Dopo aver messo l'acqua nella caldaia inferiore e la polvere nel filtro al centro, veniva chiuso il rubinetto posto sopra il beccuccio. L'acqua calda in pressione passava nella campana di vetro in alto poi, per effetto del vuoto, ridiscendeva nella caldaia. Cm. 28 x 20, capacità 4 tazze.

\mathcal{A} nickel-plated brass machine for the home,
equipped with separate filter holders, serving
valves, and a base for the cups. The brand is
Neowatt from Milan. 12 by 11 inches, 4-cup
capacity.

Anni '30

Macchina per famiglia in ottone nichelato e attrez-
zata con portafiltri separati, rubinetti di distri-
buzione e piano portatazzine. Marca Neowatt di
Milano. Cm. 32 x 28, capacità 4 tazze.

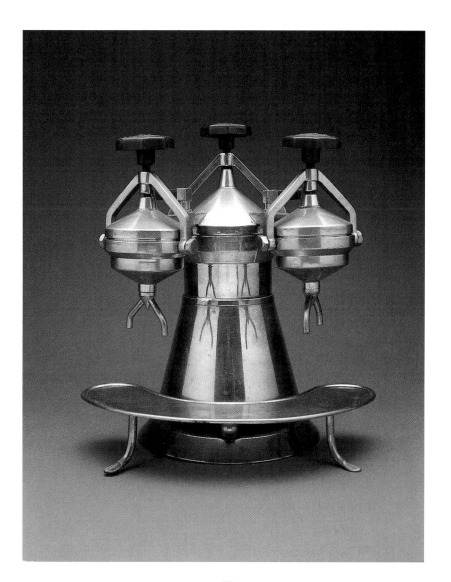

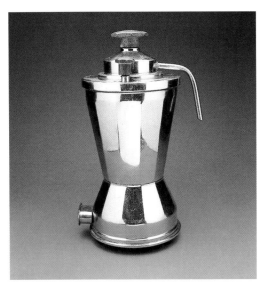

A French steam-pressure brewer made of chrome-plated brass with wooden handles. The coffee was poured directly into a serving pot. 12 by 8 inches, 10-cup capacity.

Anni '30
Macchina francese a pressione, ottone cromato e legno per le manopole di chiusura. Il caffè veniva versato direttamente in una cuccuma. Cm. 30 x 20, capacità 10 tazze.

\mathcal{A}n English nickel-silver
coffeepot. It was used primarily
to keep brewed coffee hot over
a spirit lamp. 7 by 4 inches,
4-cup capacity.

Anni '30

*Cuccuma inglese in alpacca.
Serviva soprattutto per tenere
al caldo sul fornellino ad alcol
il caffè pronto. Cm. 18 x 12,
capacità 4 tazze.*

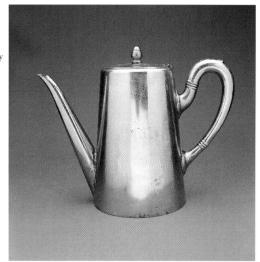

\mathscr{A} perfect example of Art Nouveau style, this percolating machine was made of nickel silver by the German company A.E.G. 18 by 12 inches, 5-cup capacity.

Anni '30

Esemplare di macchina in perfetto stile Liberty costruita in alpacca dalla ditta tedesca A.E.G. Sistema a circolazione. Cm. 45 x 30, capacità lt. 1,75.

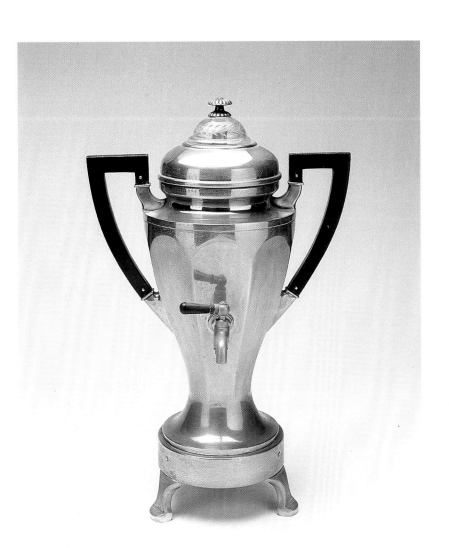

A distinctive round electric coffeemaker from R. V. of Milan. Made of hand-beaten copper with elegant fittings, it used the steam-pressure method. 7 by 10 inches, 4-cup capacity.

Anni '40

Caffettiera elettrica della ditta R.V. di Milano dalla caratteristica forma rotonda. Costruita in rame martellato a mano con buone rifiniture, funzionava con sistema a pressione. Cm. 18 x 25, capacità 4 tazze.

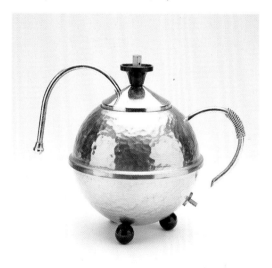

A service for Turkish coffee, of delicately engraved metal with porcelain cups.

Anni '20-'30
Servizio per caffè alla turca in metallo finemente cesellato e tazzine in porcellana.

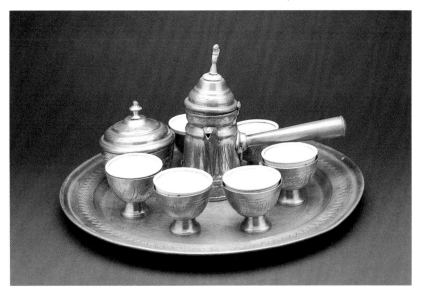

\mathcal{A}n electric coffee machine made of chrome-plated brass, from the Italian company C.G.E. The beautifully shaped coffeepot conceals an elaborate steam-pressure system with a protected filter to hold the ground coffee. 6 by 6 inches, 5-cup capacity.

Anni '40

Caffettiera elettrica in ottone cromato della ditta italiana C.G.E. La bella forma a cuccuma contiene un elaborato sistema a pressione con filtro porta caffè protetto. Cm. 17 x 15, capacità 5 tazze.

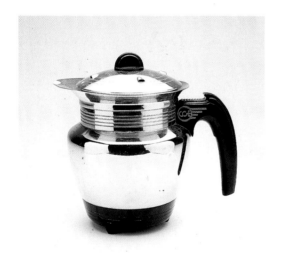

*A*n electric coffee urn made by Rowenta, a company that was also very much involved in producing commercial-sized machines. Like almost all coffeemakers built in Germany, it is a percolator. 11 by 8 inches, 8-cup capacity.

Anni '30

Macchina da caffè elettrica della Rowenta ditta che era molto interessata anche alla produzione di macchine da bar. Come quasi tutte le macchine costruite in Germania aveva il sistema a circolazione. Cm. 28 x 20, capacità 8 tazze.

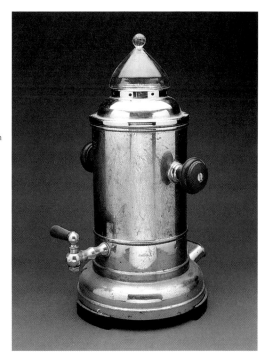

One of the many electric models produced by R. V. of Milan. This coffeemaker is made of beaten copper and chrome-plated brass and used the steam-pressure method. The fountainlike coffee-serving arrangement and the circular cup stand are unusual features. 9 by 9 inches, 4-cup capacity.

Anni '40

Uno dei tanti modelli di macchina elettrica per il caffè prodotta dalla ditta R.V. di Milano. E' in rame martellato e ottone cromato. Sistema a pressione. Originale la discesa a fontana della bevanda e il portatazzine circolare. Cm. 23 x 23, capacità 4 tazze.

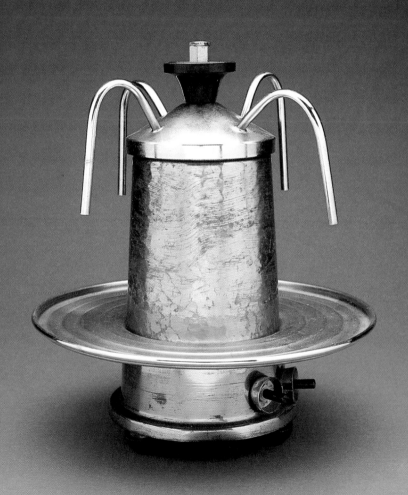

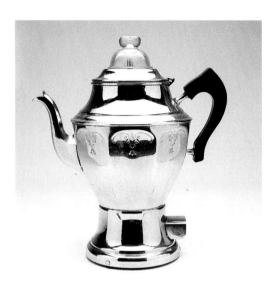

*A*n American chrome-plated brass coffee-maker, engraved on the sides. It is an electric perco-lator. 12 by 12 inches, 6-cup capacity.

Anni '40

Caffettiera americana in ottone cromato e cesellato sui lati. Funzionamento elettrico, sistema a circo-lazione. Cm. 30 x 30, capacità lt. 1,5.

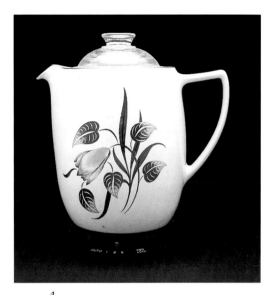

*A*n English electric coffeemaker from Russell Hobbs, this is a percolator with automatic temperature control. The pot is hand-decorated ceramic, with a clear glass lid. 10 by 9 inches, 10-cup capacity.

Anni '40

Caffettiera elettrica inglese, marca Russell Hobbs, sistema a circolazione con controllo automatico della temperatura. Ceramica decorata a mano e coperchio in cristallo trasparente. Cm. 25 x 24, capacità 10 tazze.

1 9 4 8

\mathcal{A} coffee-bar machine from Gaggia of Milan, the first piston-operated espresso machine. This model is made of chrome-plated cast brass and could work with either electricity or gas. This type of machine contributed to the worldwide success of Italian espresso makers. 22 by 20 inches, 7-quart capacity.

1948

Macchina da caffè per bar della ditta Gaggia di Milano; la prima con gruppo a pistone per "crema caffè". Esemplare in ottone fuso e cromato. Funzionamento elettrico e a gas. Questo tipo ha contribuito al lancio nel mondo della macchina da caffè italiana. Cm. 55 x 50, capacità lt. 7. ➤

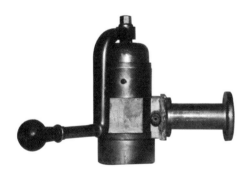

\mathcal{T}he earliest piston mechanism, which still has the horizontal handle patented in 1938. The example shown here is used by kind permission of the Gaggia family.

Il primo gruppo a pistone ancora con maniglia orizzontale, brevetto 1938. Esemplare fotografato per gentile concessione della famiglia Gaggia.

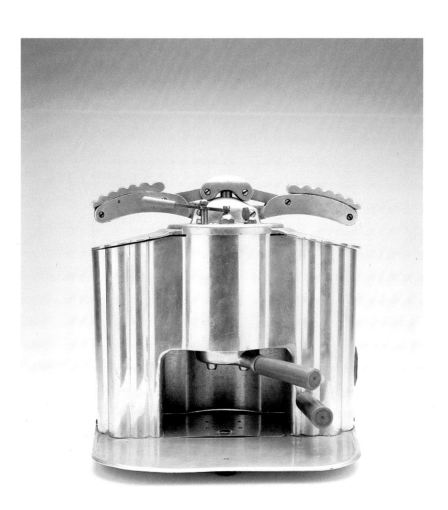

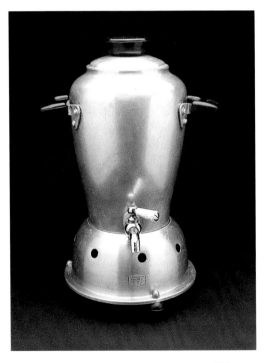

\mathscr{A} large aluminum Bouman brand Dutch coffee urn. It used a drip system with an alcohol lamp to keep the coffee hot. 14 by 11 inches, 8-cup capacity.

Anni '40

Capace caffettiera olandese, marca Bouman, in alluminio. Sistema a filtro con piccolo fornello per tenere calda la bevanda. Cm. 35 x 28, capacità lt. 2.

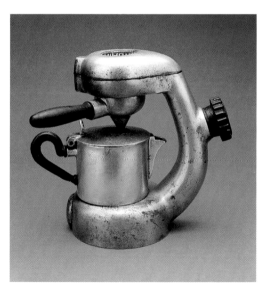

\mathcal{T}he Atomic from Milan, an aluminum stovetop coffeemaker that used the steam-pressure method. 10 by 9 inches, 4-cup capacity.

Anni '50

Caffettiera da fuoco in alluminio con sistema a pressione. Marca Atomic di Milano. Cm. 26 x 23, capacità 4 tazze.

\mathcal{A} group of mini-coffeemakers for just one cup, which use a variety of heat sources: alcohol burner, stove top, and electricity.

Anni '50

Gruppo di mini-caffettiere per una sola tazza con funzionamente diverso: ad alcol, da fuoco, a elettricità.

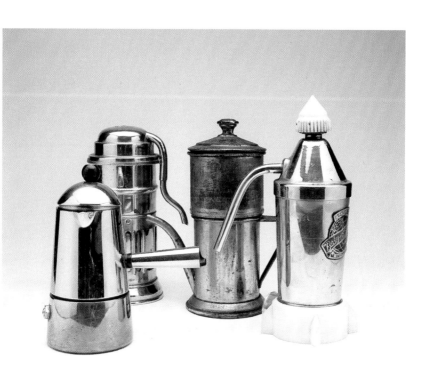

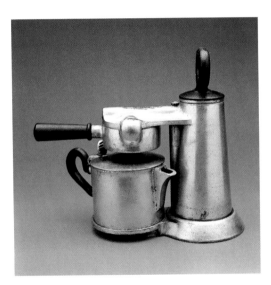

\mathscr{A}n aluminum stove-top Moka espresso maker, with a filter holder in the upper part and a pump that forced water through the ground coffee, keeping it from being over-heated. The result was a more flavorful beverage with a good layer of *crema*. Columbia brand, of Milan. 10 by 9 inches, 4-cup capacity.

Anni '50

Modelli da fuoco in alluminio, tipo Moka, con filtro portacaffè nella parte superiore e con pompa che spingeva l'acqua attraverso la polvere evitandone il surriscaldamento. Si aveva una bevanda più gustosa e con una buona crema. Marca Columbia di Milano. Cm. 26 x 23, capacità 4 tazze.

*A*n aluminum version of one of the best-known types of home coffeemakers, using the steam-pressure method, made by Vesuviana of Milan. 8 by 7 inches, 4-cup capacity.

Anni '50

Versione in alluminio di una caffettiera per famiglia tra le più note. Sistema a pressione. Prodotta dalla ditta Vesuviana di Milano. Cm. 20 x 18, capacità 4 tazze.

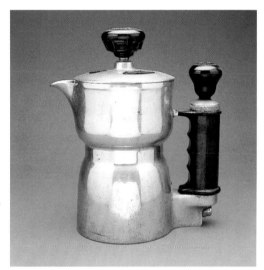

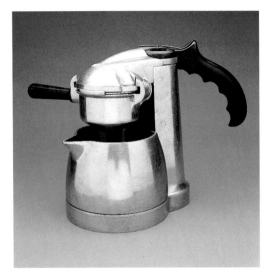

A typical Italian aluminum stovetop coffeemaker from Trimel of Milan. It has a large capacity and worked with steam pressure. 8 by 8 inches, 6-cup capacity.

Anni '50

Caratteristica caffettiera da fuoco in alluminio prodotta dalla Trimel di Milano. Di grande capacità funzionava a pressione. Cm. 22 x 20, capacità 6 tazze.

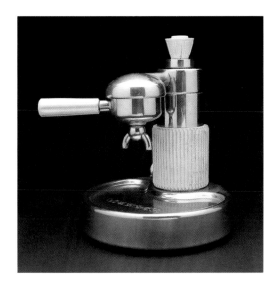

*A*n expensive, high-quality electric machine made of gold-plated brass. This Wander brand machine from Milan can serve two cups at a time. 10 by 9 inches.

Anni '50

Marca Wander di milano. Pregevole macchina elettrica in ottone dorato, di alto costo. Con sistema a pressione, poteva servire due tazze di caffè alla volta. Cm. 26 x 24.

\mathcal{A} household electric machine, the Crema Fior di Caffè was produced in Milan. Made of aluminum and using the piston system method, it was not a great success, possibly because it was considered to be too elaborate and bulky. 12 by 14 inches, 6-cup capacity.

Anni '50

Macchina elettrica da famiglia. Crema Fior di Caffè, prodotta in Milano, in alluminio e con sistema a pistone. Non ebbe successo, forse perchè considerata troppo elaborata e voluminosa.
Cm. 30 x 36, capacità 6 tazze.

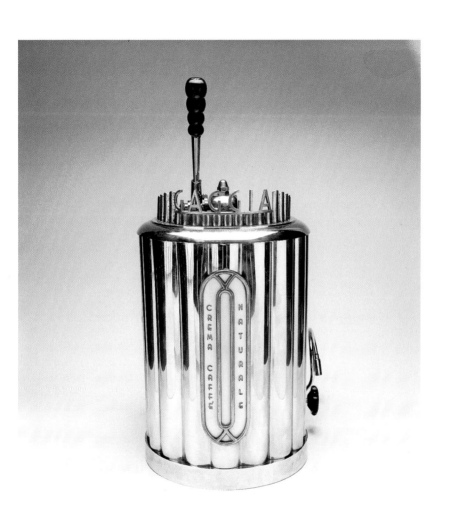

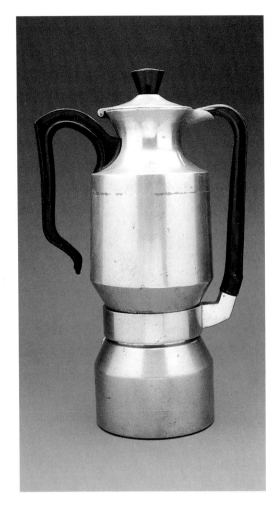

\mathcal{A}n aluminum Thermos Espress machine. Water that was heated in the boiler at the bottom rose through the coffee filter, went down the spout tube, and finally rose back up to the thermos/boiler, which also acted as a serving pot. 14 by 13 inches, 4-cup capacity.

Anni '50

Macchina da caffè, Thermos Express, in alluminio. L'acqua riscaldata nella caldaietta inferiore, dopo essere salita nel recipiente superiore attraverso il filtro del caffè, passando dal tubo del becco riscendeva nella caldaia-termos. Questa fungeva da cuccuma. Cm. 33 x 32, capacità 4 tazze.

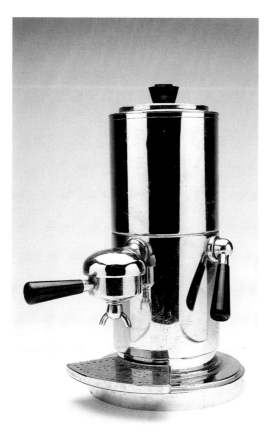

*A*n "instant" coffee-maker for the home. The handle on the side was used to regulate the amount of water that was added to the boiler in order to match the amount of ground coffee in the external filter. Made of chrome-plated brass, it is an AMA brand machine from Milan. 14 x 12 inches, 10-cup capacity.

Anni '50

Macchina per caffè istantaneo, modello famiglia. Il rubinetto laterale regolava la discesa nella caldaietta dell'acqua necessaria per la dose di caffè nel filtro esterno. Ottone cromato, marca AMA, ditta di Milano. Cm. 35 x 32, capacità 10 tazze.

*A*n unusual Mondial brand drip coffee-
maker from Milan. The hot water dripped from
the upper container through the ground coffee in
the filter below, and the brewed coffee poured
into the coffeepot at the base. 18 by 8 inches, 4-
cup capacity.

Anni '50

Originale macchina per caffè a caduta d'acqua,
marca Mondial di Milano. L'acqua calda, dal
recipiente superiore, per caduta passava attraverso
il caffè contenuto nel sottostante filtro e quindi la
bevanda si raccoglieva nella cuccuma posta alla
base. Cm. 45 x 20, capacità 4 tazze.

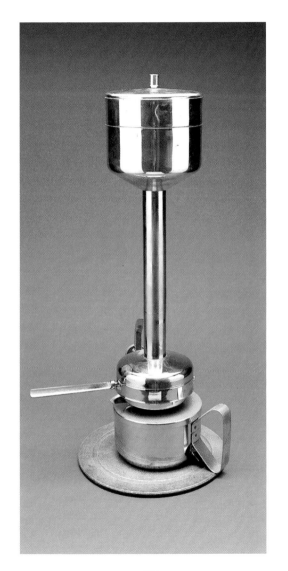

A Moka-type coffeemaker with a decora-
tive removable ceramic coffeepot. 10 by 6 inches,
4-cup capacity.

Anni '50

*Caffettiera tipo Moka con bella cuccuma
estraibile in ceramica decorata. Cm. 25 x 15,
capacità 4 tazze.*

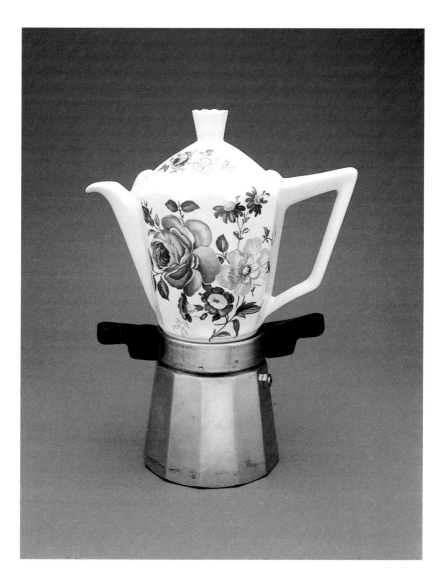

\mathcal{T}he Gilda, an electric machine for the home built by Milan's Gaggia. The two movable folding handles performed an important role: Pushing them down lifted a spring-driven piston that then forced the water out of the chamber and through the ground coffee, to make a good, creamy espresso. This attractively designed model is chrome-plated brass with wood handles and levers. 14 by 12 inches.

Anni '50

Gilda, macchina elettrica per famiglia, costruita dalla ditta milanese Gaggia. I due manici movibili, forniti di sistema telescopico, avevano una funzione importante: quando venivano abbassati, si caricava il pistone che, mediante una molla, spingeva con forza verso l'esterno l'acqua imbevuta di polvere, trasformandola in una buona crema-caffè. L'esemplare fotografato, di bel disegno, è in ottone cromato con manici e manopola in legno. Cm. 37 x 32.

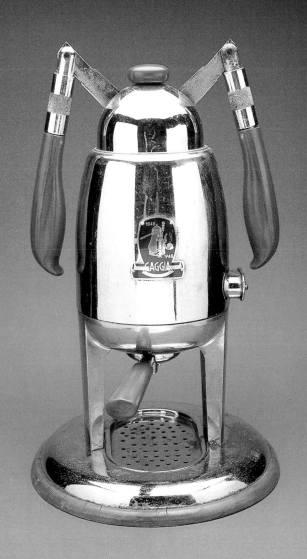

\mathcal{T}he Faema E 61, a popular pump-type machine for coffee
bars. Made by Faema of Milan, both the brewing mechanism and
the heating system are quite serviceable even by today's standards.

1960
La Faema E 61. Popolare macchina ad erogazione per bar.
Prodotta dalla ditta Faema di Milano, utilizza un "gruppo"
e un sistema a scambiatori di calore ancora oggi molto validi.

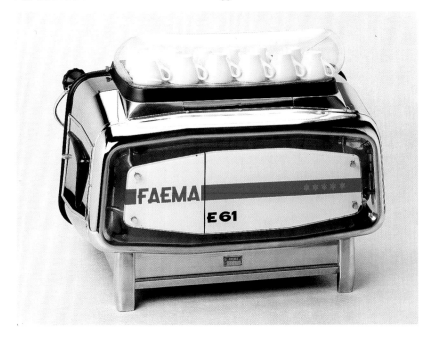

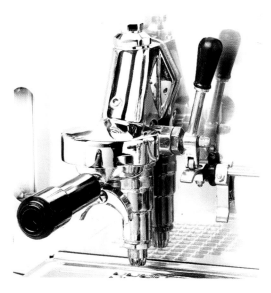

A detail of the first brewing
and serving mechanism of
the Faema E 61.
Particolare del primo gruppo
erogatore della Faema E 61.

Coffeemakers

*T*he pleasure of drinking a fragrant cup of coffee is the result of the happy combination of hot water and ground aromatic coffee beans that have been expertly roasted. The two main ways of making good coffee are infusion and pressure; though brewing methods may differ, they all depend on these two principles. In order to give a better idea of what inventors were attempting to do with the various mechanisms they used in coffeemakers, we offer a selection of the most interesting brewing methods below. Much of this technology has been used for many years, and is still being used today.

BOILING

*W*ater and ground coffee are mixed, brought to a boil, then allowed to stand for a few moments before pouring. In coffee-growing countries, the coffee is often put in a cloth bag. Coffeepots of various designs are used for this method.

Drip

The coffeemaker consists of two containers. The coffee grounds are placed on a filter in the top container, and are often pressed down with another, more porous filter. The hot water is poured into the top and seeps through the ground coffee. The brewed coffee then drips into the lower container. If this second container is large, it may be kept hot by a built-in heater. This brewing method is still widely used in Northern Europe and North America.

Vacuum

These coffeemakers, depending on their shape, are sometimes also called "balloon" or "balance" types. The coffeemaker consists of two containers, which are connected by a tube that ends in a filter. One container holds the water, and the other, usually made of glass, holds the ground coffee.

As the heating water builds up pressure, it rises and mixes with the ground coffee; then when the heat source is removed, the resulting vacuum sucks the brewed coffee back through the filter into the lower container.

Percolation

At the bottom of the machine, along with the heat source, is an inverted funnel whose upper end is connected to the coffee basket

by means of a tube. The coffee basket is perforated on the top and bottom and acts as a filter. The heat causes pressure to build up in the funnel, driving the water upward until it splashes against the lid (usually glass) and falls back into the coffee basket. There it seeps through the ground coffee before returning to the lower container. The cycle is repeated until the coffee is done.

Steam Pressure

The simplest steam-pressure machine is a water container with a filter for the ground coffee and a tube that dips into the water. As the water heats, the pressure of the resulting steam forces the water through the ground coffee and out the tube. This type of machine may have multiple nozzles for serving the coffee directly into cups, or a single tube for filling a coffeepot or other container.

Piston Pressure

This system yields espresso topped with the delicate froth known as *crema*. A water boiler is fitted with a piston mechanism that is operated with a lever. When the lever is pulled down, the piston rises, allowing the hot water to rise above the ground coffee in the filter; then the piston is pushed down by the spring and forces the water through the ground coffee and directly into the cup.

\mathcal{T}his is the most widely used system in espresso machines for both cafés and home use. The commercial types are a bit more complicated than the household models, but all are based on the same technique. The machine consists of a water reservoir, a boiler chamber automatically maintained at a temperature of 200°F, and a little pump. Pushing a button starts the pump, which draws in cold water, pushes it through the boiler where it is heated to the right temperature, and finally forces it through the ground coffee. This is a fast brewing method that avoids burning the espresso or losing its natural flavors.

A Brief History of Coffeemakers

The first cargoes of coffee were imported to Europe from the Middle East in the early seventeenth century, initially by the Republic of Venice and later by the Dutch. Early drinkers prepared this dark pick-me-up just as it had been prepared in its original homelands: The beans were roasted, then ground, and finally brought to a boil several times in water. The result was a sharply flavored, rather dense beverage that required a substantial quantity of beans and was thus expensive and beyond the reach of most people. But with time the situation began to change; coffee became known almost everywhere in Europe, and by the end of the century a number of cities had seen the advent of the early meeting places known as coffeehouses or cafés. Those of Venice, Paris, and Vienna were particularly famous.

To attract customers, a good deal of effort was invested in improving roasting and grinding techniques and coffeemakers. In the

early eighteenth century, the first primitive coffee machines were invented in Austria, Italy, and France. The English preferred to brew their coffee the way they brew their tea: The ground coffee was placed in a closed bag that was immersed in boiling water until the coffee was properly steeped. People devised ingenious ways of squeezing the bag without breaking it, to extract the most flavor from the beans and to yield a stronger brew. In another brewing method, the coffee dripped through a cloth filter known as a Biggin, possibly named after its inventor. Nevertheless, as of 1800 coffee had not yet achieved real popularity in Europe, for a number of reasons. In England, tea importers did all they could to interfere with the popularization of coffee; in France, Germany, Austria, and Italy, many people considered it overly stimulating at the least, if not downright dangerous, both to the health and to morals.

In the first years of the nineteenth century, however, coffee began its irresistible advance. Public and private coffeehouses sprang up everywhere, generating a demand to improve the quality of the beverage and a need to keep it hot and constantly available for customers. By around 1836, the first true coffee machines were being developed: large, alcohol-heated drip machines that kept the coffee hot over a double boiler and featured little spigots from which the dark, fragrant beverage was poured out directly into cups. In Italy, Neapolitan coffeepots caught on, along with the less well known but just as workable Milanese pots; German and Austrian coffeemakers operated by siphon action and percolation. The French remained

loyal to the tradition of drip coffee, while in North America, where all brewing methods were in use to some extent, the most popular coffeemaker was the percolator.

A STIMULANT TO INGENUITY AND IMAGINATION

\mathcal{A}s in any history, in the history of coffeemakers ideas and inventions are interwoven with the names of inventors, who were often imaginative and brilliant. Among so many, we have selected a few who stand out not just for their technical inventiveness but also for their aesthetic originality.

In England, for example, Robert Napier patented in 1830 siphoning and filtering, or vacuum, machines that used a glass globe or "balloon." These coffeemakers were particularly interesting because you could see the coffee being brewed; they are still made today, with modifications of course, by the Cona company. A Madame Vassieux later experimented with the glass container of this kind of coffeemaker, and patented a special filter and a little valve, also of glass, that allowed the coffee to be served from the bottom container.

Germany and Austria saw the greatest commercial success, with many varieties of models and systems that used pressure and percolation. Alongside Rowenta, such companies as A.E.G. and Krups were among the first to manufacture coffeemakers.

Italy was also part of the industry, with firms that became internationally known. Giambattista Toselli, for example, amused himself in 1850 by making coffee machines shaped like locomotives. These used a balance system that extinguished the alcohol stove automatically, and they came in a wide variety of materials: brass, silver-plated nickel silver, even artistically hand-painted ceramic. They were little gems, not uncommonly presented as gifts to celebrities who presided over the inauguration of new railroad lines. In 1860, Toselli went to Paris, where he not only continued making his original locomotive coffeemakers, but also designed and patented large machines for coffeehouse use.

Americans gradually adopted brewing methods already in existence, improved them, and repatented them—but always for use at home. They are responsible for the worldwide popularity of the percolator, patented by Landers, Frary, and Clark of Universal in the early twentieth century. As a brewing method it was serviceable enough, and could serve up a milder or stronger beverage to suit the user's taste.

Every country had inventors and companies involved in developing machines to serve hot coffee quickly at just the right strength. It was the Frenchman Eduard Loysel who patented not only a household model but a coffee machine that could really produce a great many cups within a short time. Unfortunately, at least two specially trained, full-time operators were needed to run it. This steam-pressure machine was simply enormous and was manufactured only in

small batches. Water was brought to a boil in a huge boiler, and the resulting pressure drove the liquid about three feet upward into a ceramic chamber above the boiler. Then the water came into contact with the coffee through tubes, and the brew was collected in containers below, out of which it was poured into individual cups through little spigots.

I T A L I A N - S T Y L E C O F F E E

*L*ate in the nineteenth century, household coffeemakers were still relatively uncommon in Italy. Most of the population still boiled their coffee in open pots, combining a small amount of real ground coffee with some kind of substitute. Only the privileged few could own coffee machines, most of which were made abroad, often in Austria.

Although some Italian companies—Milanese, Aquilas, S.I.M.E.R.A.C.—were making Neapolitan coffeemakers by hand, production was still on a small scale. During this period, some machines were made that used the steam-pressure brewing method. These allowed for a finer grind of coffee, thus extracting more flavor from the beans. This era saw the establishment of the first coffee importers and large roasters, but none set out to manufacture machines to brew the beverage. They left this to small industry, and though many people tried, they never found a really workable brewing method that

could both get maximum flavor out of the ground beans and provide a hot beverage within a short time.

As Italian industry began to evolve in the early 1900s, people began designing coffeemakers. In 1901, the Milanese engineer Luigi Bezzera filed a patent for a restaurant machine with a boiler that could be heated with either gas or electricity. The machine could be fitted with one to four brewing-serving mechanisms, depending on the size of the reservoir. But the real novelty was that each mechanism, or group, could hold from one to three ground portions of coffee in appropriately sized filters. Turning a handle first added water to the ground coffee, followed by steam at a pressure of 1.5 atmospheres. The resulting beverage went directly into the cups as the customers watched, allowing them to begin savoring the brew before it had even touched their lips. This was the birth of espresso.

This 1901 patent was acquired in 1903 by Desiderio Pavoni, founder of the company that still bears his name. In 1905, the company started making machines with good success. World War I put a temporary damper on the Italian coffeemaker industry. But in 1920, about ten companies in Milan and Turin found ways to get around the patent and began making these machines. Espresso became known not only in Europe but soon in America as well, and finally all over the world. The system did have one defect: Forcing the steam through the coffee at a relatively slow rate of speed produces a bitter or "burnt" flavor. To avoid this, a Milanese named Cremonesi developed

around 1938 a rudimentary piston assembly operated by a horizontal handle, fitting it to a machine at Achille Gaggia's bar, Achille. Gaggia tried the system and asked for a few modifications, but the outbreak of World War II caused a seven-year halt of industrial development in Italy, during which time Cremonesi died.

In 1945 Gaggia resumed testing of the piston machine, making further modifications to the system, and in 1946, by agreement with Cremonesi's widow Signora Scorza, he had his own lever mechanism ready. This system drew only water (not steam) from the pressurized boiler, then filtered it through the coffee by means of a spring-driven piston that developed a pressure of ten atmospheres. The burnt taste had been eliminated, and the coffee was smooth and creamy. The age of *crema*, the fine layer of foam that distinguishes an excellent cup of espresso, had begun.

At first Gaggia's company made only brewing and serving mechanisms that could be attached to existing equipment from other makers. But in 1948 they decided to expand production to include the entire machine, thereby lending substantial impetus to the piston-powered machine's popularity. Other companies quickly adapted the new technology, and the Italian espresso machine became preeminent worldwide.

It was still hard work operating the levers, however, and the espresso was slow to arrive: two little espresso cups took about one minute to fill. Eventually the system was altered by new innovations,

although the old piston machines still enjoy a certain market even today due to their low maintenance requirements.

Meanwhile, Ernesto Carlo Valente's company Faema was founded in Milan in the late 1940s. It started out using the piston method, but late in the 1950s developed a new system: A pump forced the water directly through the coffee, while the machine kept the water at a constant temperature of around 200°F. This innovation was a success, and in 1961, the company launched the famous E 61, known as the pump machine. It offered two advantages: First, it could make two cups of espresso in about twenty seconds, saving a considerable amount of money and effort; second, the water came fresh from the plumbing, instead of being stored in a tank. After passing through a decalcifier, the water was fed to the pump, where it was pressurized to approximately nine atmospheres, then went on to heat up in the heating tubes that crisscrossed the boiler. Finally, in the brewing and serving mechanisms the water was forced through very finely ground coffee, from which the maximum flavor was extracted. The resulting beverage was a dense, flavorful espresso that always tasted the same, thanks to the even temperature of the water.

Since the water was decalcified, the parts of the machine that carried water or coffee always remained clean, and you could count on a long service life. Some of these machines have been making espresso for twenty-five years and longer, with only minor mainte-nance. This method is still much in use today, including in home

machines. Though smaller in size and simpler in design, these still make it possible to brew an excellent cup of espresso at home.

Thus ends our brief history of the coffeemaker, a useful device that has become integral to our everyday life. From the antique coffeemakers that presided over the old coffeehouses to modern espresso machines in coffee bars or at home, the pleasant ritual of coffee has endured for centuries. In many countries, modern coffee bars may have replaced some of the coffeehouses where people once calmly sipped their aromatic beverage, sitting down together to talk and gossip, to read the paper or write—but no prophet worthy of the name would predict the disappearance of the cup of coffee, one of life's most subtle pleasures.

Acknowledgments

All the coffeemakers photographed here belong to the private collection of Ambrogio Fumagalli. Our warmest thanks to Mr. Fumagalli for his assistance in the production of *Coffeemakers*.

Bella Cosa